IMAGES
of America

COLUMBUS

IMAGES
of America

COLUMBUS

For Pam
My able assistant who
helped make this book
a reality. Love and blessings,

Patricia M. Mote

Patricia M(other) Mote

ARCADIA

Published by Arcadia Publishing
Charleston SC, Chicago IL, Portsmouth NH, San Francisco CA

Printed in Great Britain

Library of Congress Catalog Card Number: 2004117751

For all general information contact Arcadia Publishing at:
Telephone 843-853-2070
Fax 843-853-0044
E-mail sales@arcadiapublishing.com
For customer service and orders:
Toll-Free 1-888-313-2665

Visit us on the internet at http://www.arcadiapublishing.com

For Pamela, John, and Susan, whose lives were immeasurably enriched by growing up in the uncommon town of Columbus.

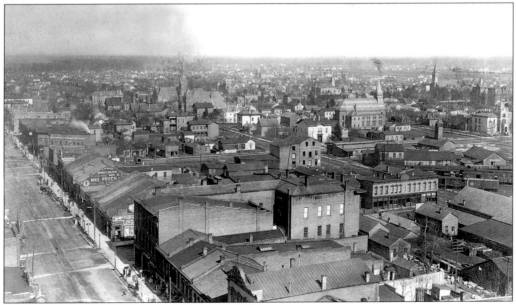

Above is a view of Columbus from the Bartholomew County Courthouse in the late 19th or early 20th century.

CONTENTS

ACKNOWLEDGMENTS

My sincere thanks to Michele Bottorff, executive director of the Bartholomew County Historical Society, who gave me access to the society's files and permitted me to reproduce images for this book. She was very gracious and helpful in every way. My daughter, Pamela Weinantz, photographed many of the sites for chapters four and five and ably researched details as well. Ralph and Nancy Schumann, Susan Whittaker, Mary Ellen Sweet Grossman, and Richard Weinantz all provided useful information.

The History of Bartholomew County, Volumes I and II, were invaluable tools that the BCHS loaned to me for the duration of this project. Other print sources were *The Evening Republican; I Discover Columbus* by Will Marsh; *The Engine That Could* by Jeffrey L. Cruikshank and David B. Sicilia; *Time*, December 5, 1977; *National Geographic*, September, 1978; the *Wall Street Journal*, September 1, 2004; the *Courier-Journal.com*, August 22, 2004; and *IndyStar.com*, August 16, 2004. David Sechrest's website, *Historic Columbus, Indiana*, yielded a wealth of information, as did websites from the Columbus Visitors Center; the Columbus Chamber of Commerce; Cummins, Inc.; ArvinMeritor, Inc.; the Columbus Philharmonic; and kidscommons.

On a personal note, my research gave me the opportunity to return several times to Columbus, where our family lived from 1964 to 1974, and where I was a teacher in the Bartholomew County schools. I realize more than ever what a unique community Columbus is and how the aesthetics of the surroundings affected our lives in such a positive way. I was thrilled to learn in my research that my own great-grandfather, Joseph E. McDonald, spoke at the December 29, 1874 dedication of the Bartholomew County Court House. An Indianapolis attorney and former Indiana Attorney General, he had just been elected to the United State Senate.

Credits: Images are courtesy of the Bartholomew County Historical Society except as follows:
Patricia Mote: pp. 40a, 62a, 68b, 69b, 86b, 89a, 90, 100, 105, 106a, 110a, 111, 114, 126b, 128b
Pamela Weinantz: pp. 42, 44a, 65, 66, 67, 70, 71, 72a, 73, 75b, 77, 82, 85b, 91, 92, 93, 94, 95, 102b, 106, 107, 113, 126a
Rhonda Bolner: pp. 61, 75a,
Paul McCreary: pp. 59, 62
Richardson Printing: p. 72b
Evening Republican: p. 63

INTRODUCTION

When the hardy settlers of Columbus came over the Appalachians and down the Ohio River by flatboat and began to put up permanent public buildings, they learned the hard way to build them to last. The first two court houses in Bartholomew County were dilapidated and crumbling after only a few decades.

In 1871, contracts were let for the present court house which today stands as the *grand dame* of a town known as an architectural showcase. Dedication on December 29, 1874 of the Bartholomew County Court House was "an event in the history of Indiana . . . because it is the finest, most elegant and costly building . . . by all odds in the State." So wrote O.O. Shealey, correspondent for the *Louisville Courier-Journal*. While Shealey acknowledged that some "farmers and solid men of the county" might be skeptical of the county spending a quarter-million dollars for a court house, he wrote: ". . . these people up here are brimful of enterprise and energy and believe and live in the spirit of progress. So they went to work, and behold the fruit of their labor."

This book covers roughly the 100 years following the building of that French Second Empire-style court house. It will attempt to capture the spirit of Columbus leading up to the architectural awakening that was sparked in 1942 by the building of the First Christian Church. Beginning in the 1960s, the foresighted generosity of the Cummins Engine Foundation spawned a unique townscape that adults got used to and where children have grown up with respect for order and an aesthetic quality in their surroundings. Some forty public buildings, their architects selected from a prestigious group and their fees underwritten by Cummins, appeared on the tabletop Columbus landscape. This ignited Columbus' architectural explosion, now its greatest attraction.

Generally hailed as the shaper of Columbus' identity, the late J. Irwin Miller, chief executive officer of Cummins Engine Company until his retirement in 1977, often stated he had a love affair with his hometown and wanted to remain in it. To attract the brain trust and skilled workers Cummins demanded, Miller set out to elevate the quality of life in a then-ordinary, small Midwestern town. The architectural program administered by the Cummins Engine Foundation emerged as a major facet of that plan. It produced a decided ripple effect upon the value and emphasis the town would place upon the arts in general.

Although Columbus is noted for its contemporary buildings, respect for tradition is evident. Dozens of Victorian-style homes have been restored in the near-downtown area. Old buildings are not always razed to make way for new ones; a former city hall, a power house, and several school buildings—all built in the late 19th century—have been converted. The limestone world headquarters for Cummins, Inc. surrounds a century-old brick mill that now houses meeting rooms and a cafeteria. These are evidences of the Columbus way of doing things: blending what is old and

valued with contemporary, daring ideas. As *Time* magazine quoted then-Mayor Max Andress in 1977, "A sense of quality has rubbed off all over Columbus."

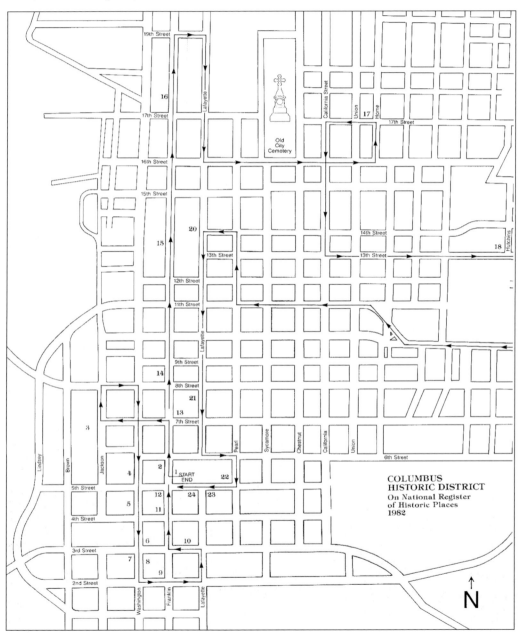

The Columbus Historic District, shown by the shaded area, contains more than 600 buildings. When the District was listed on the National Register of Historic Places in 1982, 91 of these structures were judged outstanding, according to the *History of Bartholomew County, Volume II*, because of "excellent unaltered conditions, significant architectural style, or significance of prior owners in community history."

One

DOWNTOWN

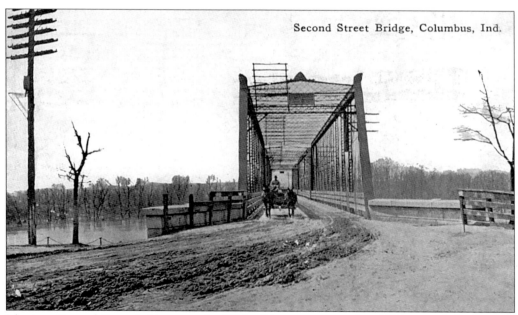

Second Street Bridge, Columbus, Ind.

The iron Second Street bridge over the White River, constructed in 1884, provided a gateway to Columbus for residents of the western part of the county. It replaced a wooden covered bridge a short distance downstream at the foot of Vernon (Second) Street. This iron bridge was in use until 1951, when it was replaced by the new concrete Tipton bridge (Third Street). Today, a brightly colored metal bridge welcomes residents and visitors to Columbus.

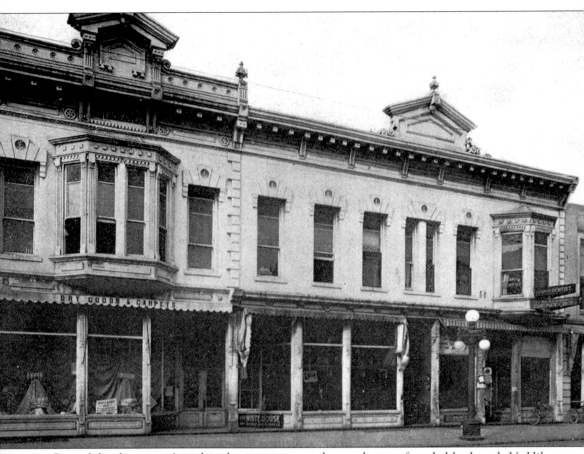

One of the downtown's earliest businesses was a dry goods store founded by Joseph V. Hilger around 1887. It was first located in the former First National Bank Building at 333 Washington Street, just north of the present Zaharako confectionery.

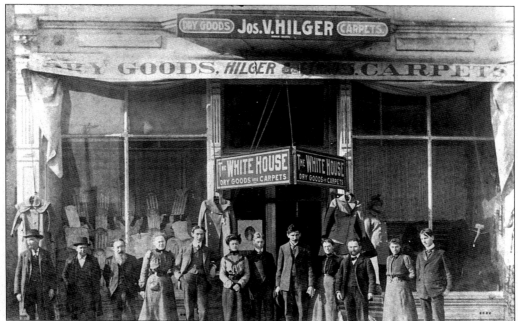

Hilger (above, right in doorway) employed a number of persons in his first dry goods store. Later, he moved his business to 422 Washington Street. Known as The White House department store, it offered three floors of merchandise and operated under the same ownership until the late 1960s.

Joseph V. Hilger's family came to America from Austria in 1836 and located in Louisville, Kentucky. His father, Andrew Hilger, came to Columbus in 1874 where he opened a tailor shop "which became one of the best shops in the city." Joseph Hilger (above) took a great interest in civic affairs and became known for his frequent lengthy and thought-provoking letters to the editor of the local newspaper.

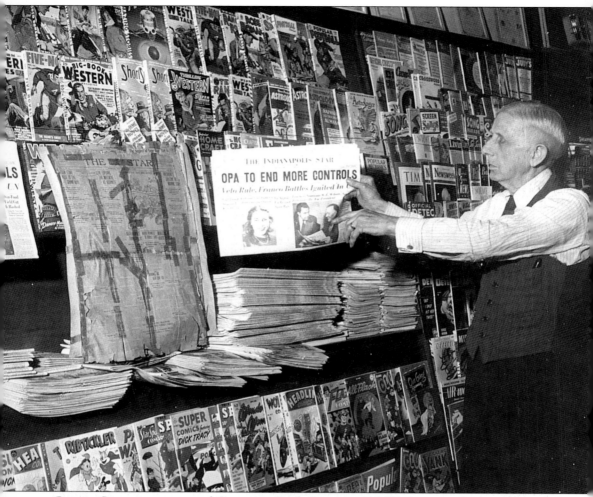

George Cummins, owner of Cummins Book Store at 406 Washington Street, points to a post-World War II headline of the day. Housed in the Custer Building, the bookstore is the oldest Columbus store that is operating in its same location since 1892. In the *Evening Republican*, January 30, 1892, readers were first exposed to what became Cummins' trademark one-liner ads, such as "Fine Line of Stationery at Cummins," "Cornette Cigars at Cummins," and "Tobacco at Cummins."

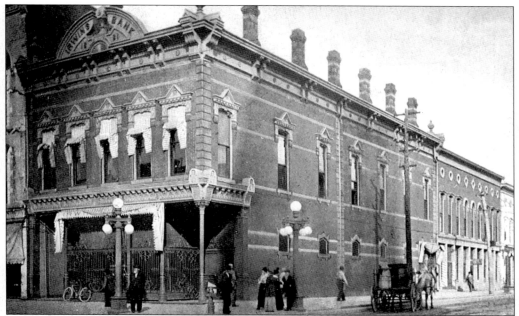

Originally, Joseph I. Irwin ran a dry goods store in this building at the northeast corner of Third and Washington Streets. After he established Irwin's Bank in 1871, he remodeled the building in the Italianate style. According to the *History of Bartholomew County, Volume I*, "Owing to the well known financial ability and integrity of its owner, (the bank) did a large and profitable business." By 1895, Mr. Irwin decided to devote all of his time to banking, and Irwin's Bank took over the entire building.

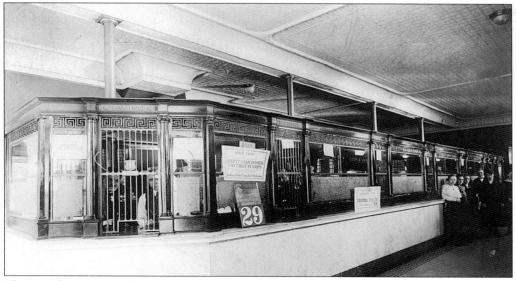

This was the interior of Irwin's Bank about 1908. Family member Mrs. Clementine Tangeman verified that William Glanton Irwin, son of Joseph I. Irwin, is the man with the bow tie to the far right of this picture. He was known as Will or W.G. At left is Hugh Miller. Archie Cox is at right. The women may be Lula Patterson and Bernina Crater.

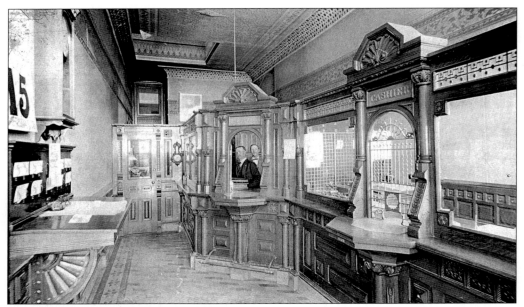

The First National Bank on the southeast corner of Fourth and Washington Streets began business in 1865 under the National Bank Act of Congress. The president was R. (Randolph) Griffith, and F.J. Crump was vice president. F.M. Bonfill was cashier. Crump later became president and one of the city's most enterprising entrepreneurs.

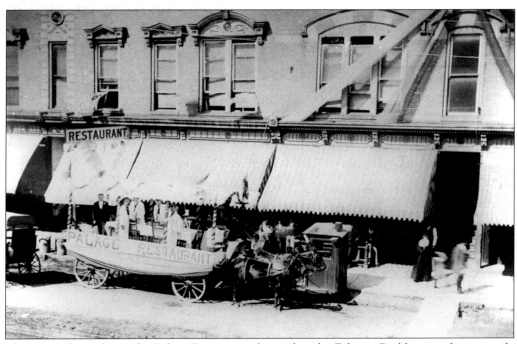

This 1903 photo shows the Palace Restaurant, located in the Fehring Building on the west side of Washington Street between Fifth and Sixth Streets. It is unknown whether the horse-drawn wagon was a float of some sort or just the Palace Restaurant's way of advertising.

Since 1900, members of the Zaharako family, immigrants from Sparta, Greece, have operated the soda fountain and candy store at 329 Washington Street. Gust Zaharako, a nephew of the owners of Zaharako Brothers Confectionery, started a dairy business named the Olympia Dairy for Mount Olympus, home of the gods of ancient Greece. The dairy operated until 1972. Gust Zaharako also operated a dairy bar and lunchroom across from the former Columbus High School (now Central Middle School) until 1984.

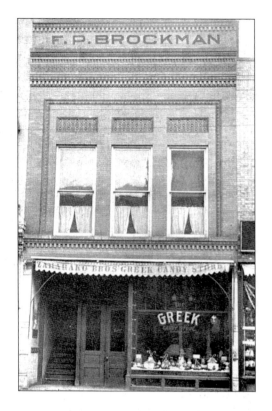

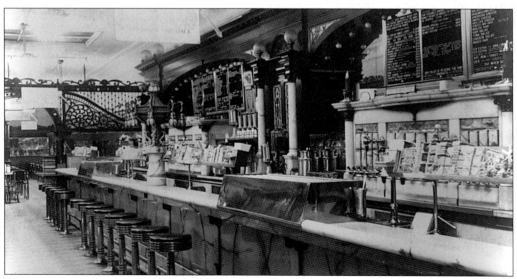

Treats from the ornate Mexican onyx soda fountain, originally used at the 1904 St. Louis World's fair, have made "The Greek's" a tourist attraction on Washington Street as well as a popular lunchtime gathering place for locals. In 1911, the Zaharakos added a 40-foot onyx and marble serving counter and an elaborate Tiffany stained glass lighting fixture mounted on a high pedestal.

15

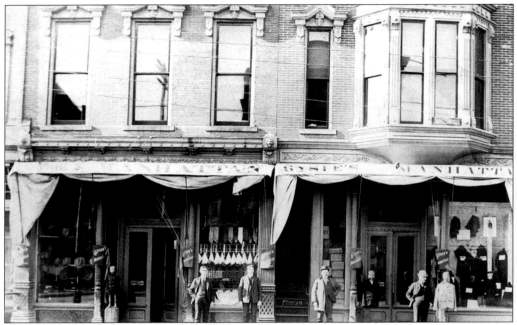

The Gipie Brothers Manhattan Clothing Store was located in the 300 block of Washington Street.

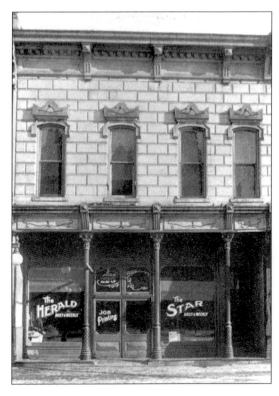

Located at 225 Washington Street, this building housed *The Herald* newspaper, established in 1881 by George E. Finney and Charles H. Lacy. A Democrat in politics, the paper lasted only until 1886 under these owners. *The History of Bartholomew County, Volume I* gives no record of a Columbus paper named *Star*. Presumably the Herald office was the distribution point for the Indianapolis paper by that name.

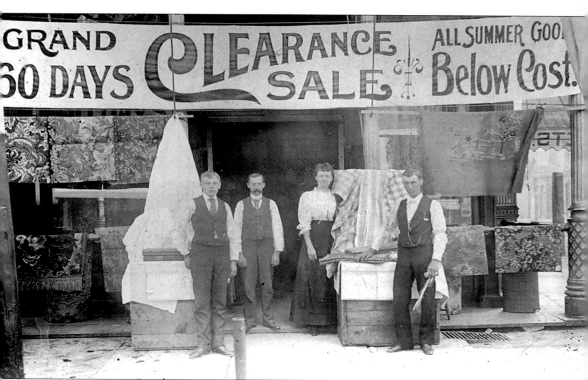

At Third and Washington Streets, Meyer Dry Goods Store employees attract buyers to a summer clearance sale. Pictured, from left to right, are: Will Lowe, nephew of H.L. Rost, prominent Columbus jeweler for many years; Fred Meyer, owner; Mattie Vorwald, probably a relative of grocer John Vorwald; and Frank Fulwider.

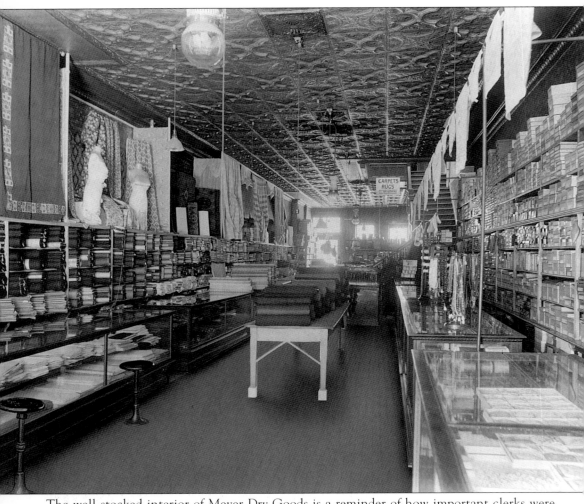

The well-stocked interior of Meyer Dry Goods is a reminder of how important clerks were in the days before self-service became a way of life for shoppers in the 20th century. On the second floor, shoppers could view displays of carpets and rugs. Note the ornate tin ceiling in this building.

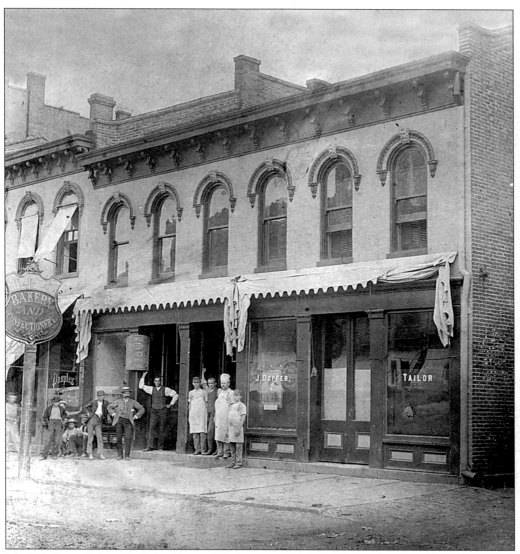

The Kitzinger Bakery, built by George Kitzinger at 321–323 Washington Street, is shown here around 1882. The bakery was a landmark business in Columbus for 92 years, closing in 1954. Tailor J. Dopfer's shop (right) later became the Kitzinger tavern.

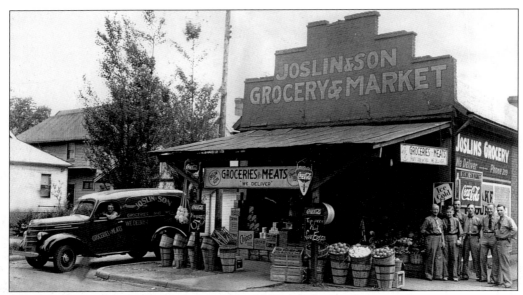

The delivery truck at Joslin Market at 303–305 Fourth Street illustrates the common practice of grocers in the 1930s of delivering orders to the homes of customers. In those days before two-car families, homemakers could order their groceries by phone, have the charges placed on a running account at the store, and the delivery truck would arrive at their door within a few hours. Note the neatly dressed store personnel.

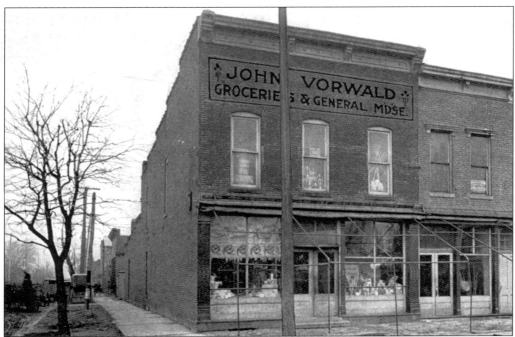

Vorwald's Market at 302 Third Street typified smaller merchants who combined groceries and dry goods merchandise in a general store establishment. It was located on the site of the present Commons Center.

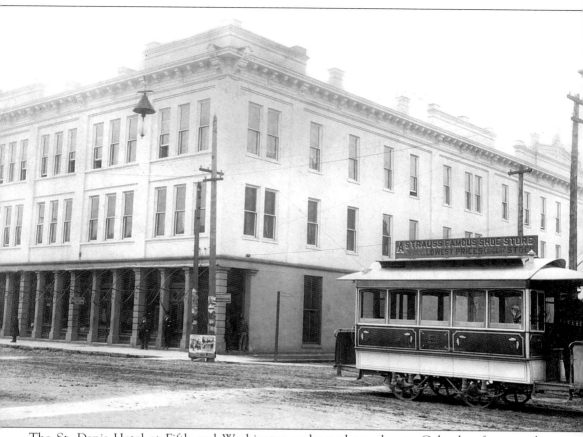

The St. Denis Hotel at Fifth and Washington welcomed travelers to Columbus for several generations. Patrick McCormack, prominent builder and contractor (see page 28), was owner of the St. Denis. Earlier photographs show a fourth-story cupola on the structure. The street car line, founded by John S. Crump in 1890, used mule power for the first few years of existence.

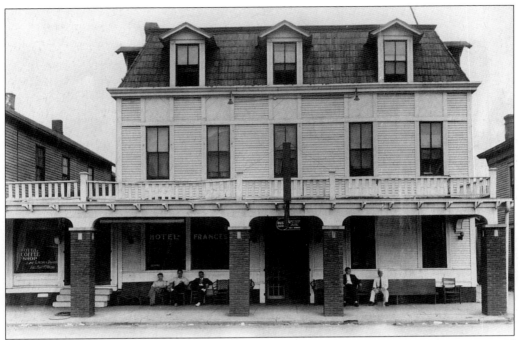

Known at one time as the Columbus Hotel, the St. Frances Hotel appears to have attracted guests or passersby to enjoy its shady porch. Iron fire escapes were not widely used as yet. This frame structure probably had an early version of a fire escape—a rope coiled in a chintz bag fastened below the window.

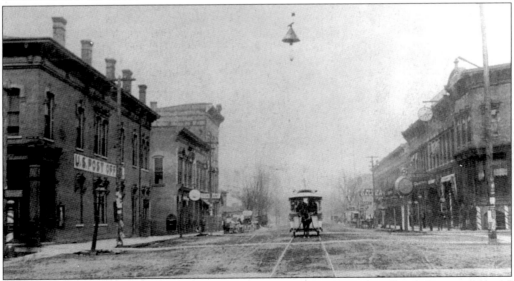

Unpaved downtown street crossings were sprinkled to keep down dust, but ladies complained that their long skirts became damp and bedraggled. Note the horse-drawn streetcar and the carbon streetlamps. In 1886, 46 of these lamps were installed on Columbus street corners. These required new carbons twice each week. Henry Euberroth (and later Ben Hull) are recorded as daily walking from corner to corner, lowering the lamps and installing new carbons.

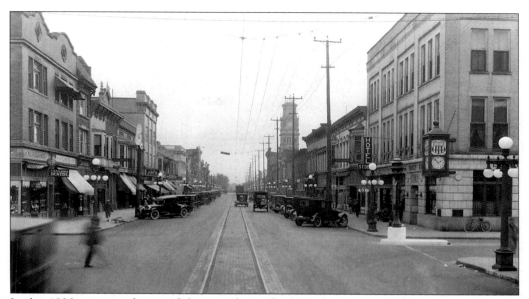

In this 1930s view south toward the court house from Washington and Fifth Streets, diagonally parked automobiles compete for space with interurban tracks. The H.L. Rost jewelry store is at left on the southeast corner. By this time, the owner of the St. Denis Hotel that had originally occupied the entire southwest corner (see page 21) had sold some of its property to the Union Trust Company. The bank's multi-sided clock became a familiar landmark.

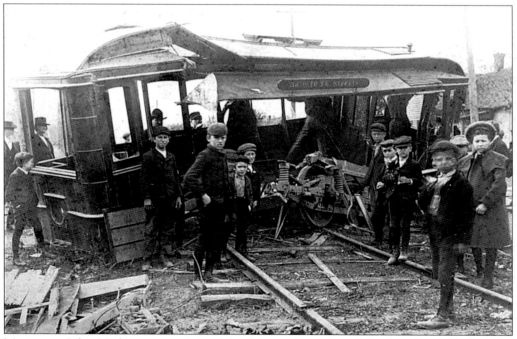

Motorman John Nickerson was injured in this wreck on the Columbus Street Railway on November 3, 1900. He died three days later. Fortunately, there were no passengers on the car at the time of the accident.

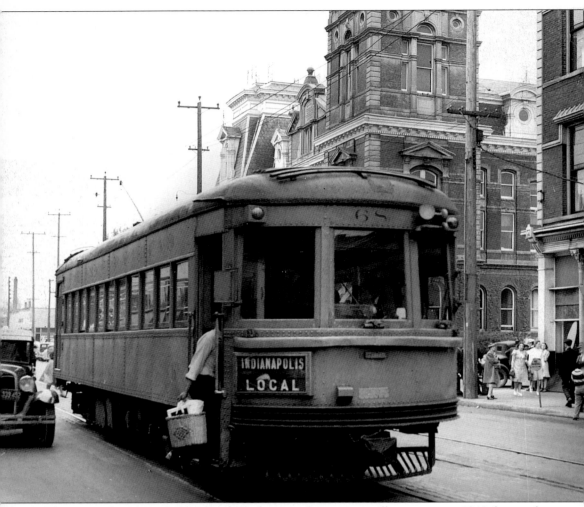

This interurban train at Third and Washington Streets was still operating in 1940, but its days were numbered. As more people could purchase automobiles, the interurban tracks were taken up—Americans preferred to travel in the privacy and convenience of their own vehicles.

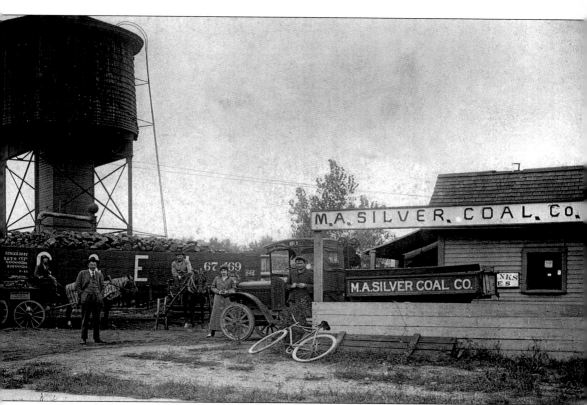

M.A. Silver Coal Company had an advantageous location beside the railroad tracks. The water tower indicates the possible location may have been at Railroad Square, the site of the present First Christian Church.

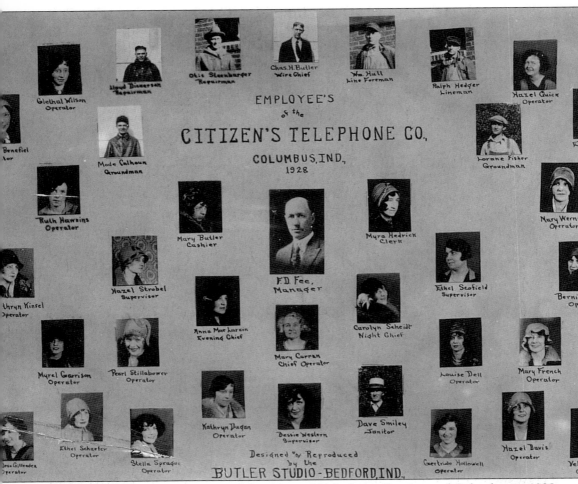

Pictured here are the employees of the Citizens' Telephone Company of Columbus in 1928. The arrival of the telephone company opened the doors of employment to many women who became telephone operators.

This is the site of the post office at Seventh and Washington Streets, before breaking ground.

This view looks north on Franklin Street in the 1880s; the Presbyterian Church, built in 1875 and still in use, is on the right, and the Beatty-Donner house (see page 29) is on the left. Note the carbon streetlight.

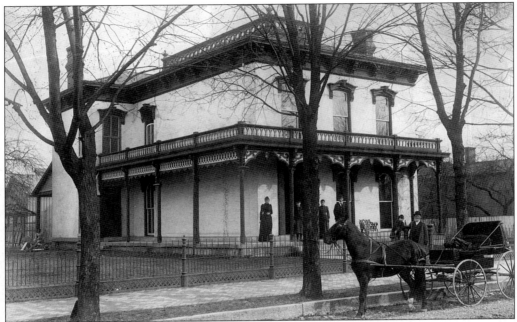

The stately home of the Patrick Henry McCormack family was at 724 Washington Street. McCormack was a well-known contractor and builder. During his years of erecting many public structures throughout the state, including the Bartholomew County Court House, his firm, McCormack and Sweeney, put up 12 bridges in Johnson and Bartholomew Counties. Mr. McCormack took an active role in the Indiana Democratic Party. He was twice elected to the Indiana General Assembly, but he later resigned because of pressing business interests.

Dr. and Mrs. George T. McCoy enjoyed a tree-shaded porch at their home at Twelfth and Pearl Streets. In front is believed to be Fred McCoy, one of the couple's six children. Dr. McCoy moved to Columbus from Lancaster, Indiana, in 1884. He is said to have "enjoyed a large and lucrative practice," and he was appointed United States Examining Surgeon in 1884.

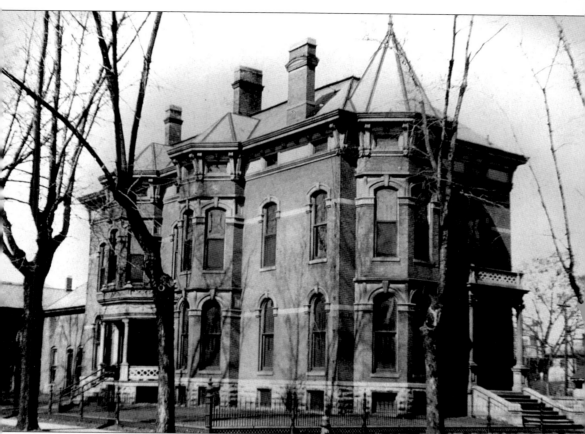

The Beatty-Donner House was situated on the northwest corner of Seventh and Franklin Streets. It is the present site of the Indiana Bell Telephone Switching facility (see page 72). Josiah Beatty, a prosperous retired farmer, built the home in 1877 when he married Emma Swisher. The *Columbus Republican* described it as the "latest, most substantial and most expensive home in Columbus." It later became the home of the Fred Donner family. Donner was a Columbus jeweler for over 50 years and was also in the milling business. Of the eight Donner children, the oldest, William Henry (Will) Donner, prospered in the steel business and became a noteworthy philanthropist. Although he left Columbus at age 30, his benevolence created Donner Park and its pool. Although not an alumnus of Hanover College, he also became a liberal donor to that institution.

George C. Caldwell, a well-known Columbus contractor who became mayor, constructed buildings for the 1904 World's Fair in St. Louis. The home he built for his family on Twenty-fifth Street, east of Central Avenue, resembled one he had built for the Arkansas exhibit at the World's Fair. That historic home, long since demolished, had a history as a tea room, a dance pavilion, and finally a temporary home for the newly organized congregation of the North Christian Church in 1956.

In May 1902, the Elks Club (B.P.O.E.) sponsored a "Grotesque Parade." One of the highlights of the parade was the "King of the Dump."

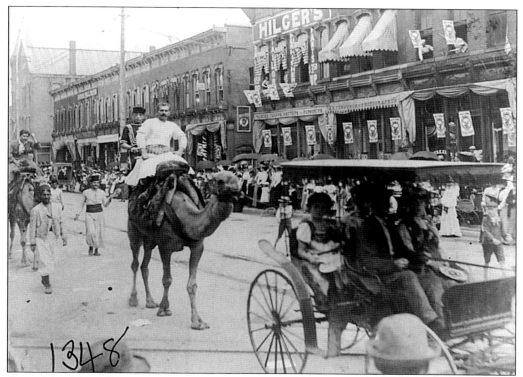

One of the featured attractions of the 1902 Elks parade was a live camel, a peculiar sight on the streets of Columbus.

Proudly proclaiming their town as the "best in Southern Indiana," members of the Columbus Kiwanis Club gathered to take the interurban to a convention in the 1920s. The train stands in front of what is now The Commons.

This parade in 1917 honored O.E. Stam and other recruits who were entering the armed services. This is a view of the 300 block on Washington Street, looking north.

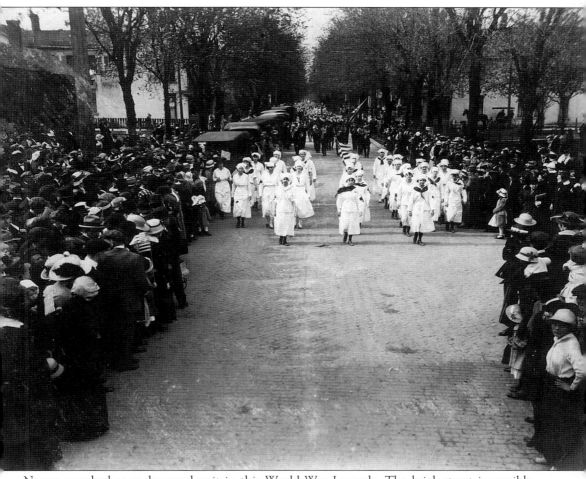

Nurses marched as an honored unit in this World War I parade. The brick street is possibly Franklin Street. Note that even young girls (right) wore hats for this festive occasion.

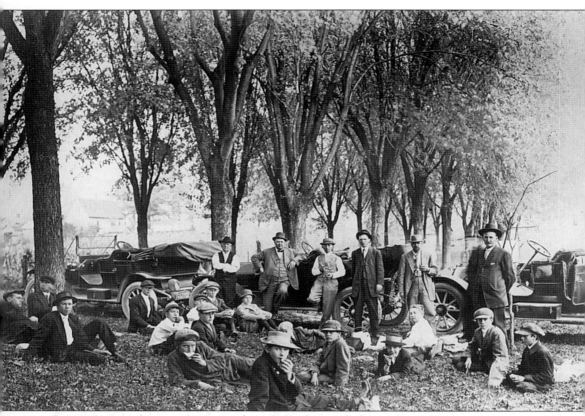

By 1915, enough cars were owned in Columbus and the vicinity that motoring became a Sunday pastime. Pictured here (in no particular order) are these enthusiasts: Roy Friedersdorff, Sherman McGaw, Gordon Reap, William Schad, Perry Setser, Daniel Miller, Dean Walker, Paul Robertson, James Calens, Earl Talkington, Thomas Brockman, and Floyd Spaugh.

Two

INDUSTRIES

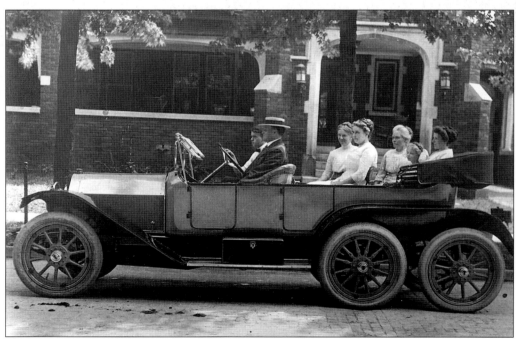

This Reeves Sexto Auto is proudly driven by M.O. Reeves (front seat), accompanied by his son Paul. In the second seat are Mrs. Sam Jeth McGride and Mrs. M.O. Reeves; Mrs. Noble McKnight, Margie McKnight, and Mrs. O.B. Shank are in the rear seat. This photo was taken in front of Gerney Reeves' home.

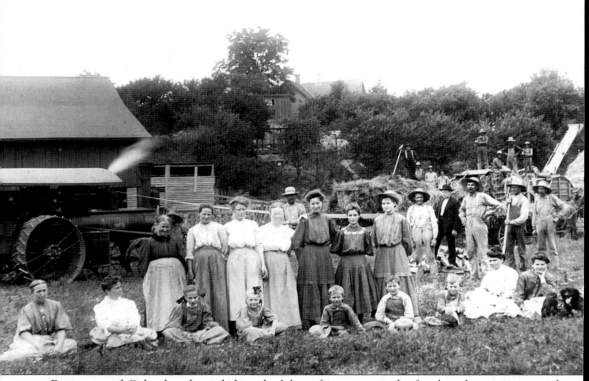

Farms around Columbus depended on the labor of everyone in the family at harvest time, and neighbors often pitched in to help one another. This photo is at the Henry Michaels' farm around 1903. According to the *History of Bartholomew County, Volume II*, most farms around the turn of the century were small, averaging around 80 acres.

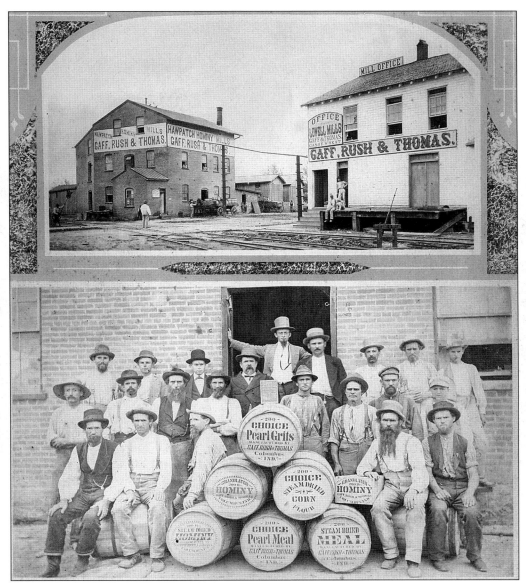

The Gaff, Rush & Thomas Mill originally was built at the southwest corner of Fifth and Franklin by John V. Storey. This was opposite the Storey residence, now the Columbus Visitors Center (see page 93). A few years later, Storey sold the mill to T. and J.W. Gaff, who took Thomas Rush and Joseph Gent into the firm and converted it to make hominy (see page 41). Employee James Vannoy experimented and ultimately developed a process resulting in Cerealine. Initially, it was sold not as a breakfast cereal, but in bulk for food preparations and beer making. At one time, several carloads were shipped to Germany daily. In 1884, Cerealine appeared in grocery stores under its own name as a cereal. The Cerealine company moved to Indianapolis in 1892 and changed its name to the American Hominy Company. This was a disappointment to Columbus since Cerealine was the first product of Columbus to be sold nationally and internationally. The company failed the next year, however, in the Panic of 1893.

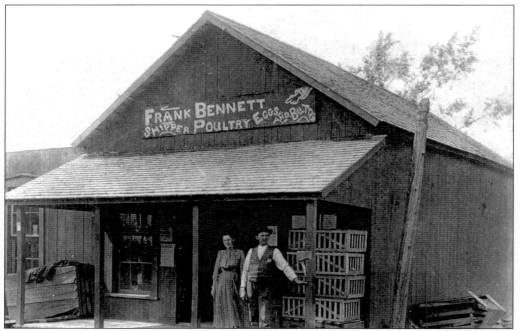

For 20 years, Frank Bennett and his wife Carrie operated their poultry business at 113 Second Street. This enterprising couple also worked together as owners of a rooming house and a lunch stand at 214 Second Street.

Dressed in his Sunday best, Vernie Rogers could be headed for the Bartholomew County Fair to exhibit his goat. Dating back to 1852, fairs operated at the Twenty-fifth Street Fairground (now site of Fair Oaks Mall). From 1910 to the 1960s, the fair was the biggest annual event in the county. (*History of Bartholomew County, Volume II.*) Then a separate 4-H Fairground opened south of Columbus, causing a drop in attendance.

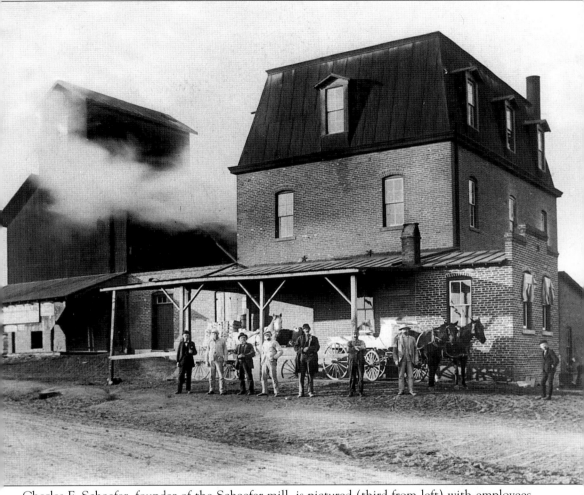

Charles F. Schaefer, founder of the Schaefer mill, is pictured (third from left) with employees around 1900. Charles Schaefer and his brother Albert built the mill at Third and California Streets in 1888, using lumber from trees felled at the Schaefer farm near Jonesville and cut into timbers at the Schaefers' sawmill.

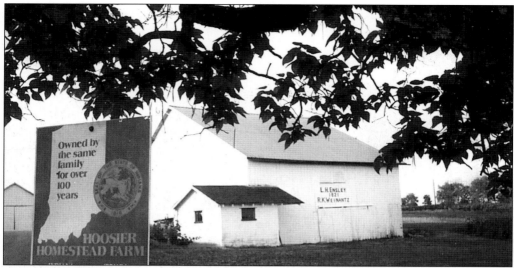

Although Columbus is home to several major corporations and scores of smaller manufacturers, the corn, soybeans, and wheat from fields that surround the town still help support its economy. This farm, started by the Ensley family in 1821, is now owned and operated by Ensley descendants Richard and Randall Weinantz. They farm nearly 1,100 acres. The Indiana Department of Commerce has recognized it as a Hoosier Homestead Farm, one owned by the same family for over 100 years.

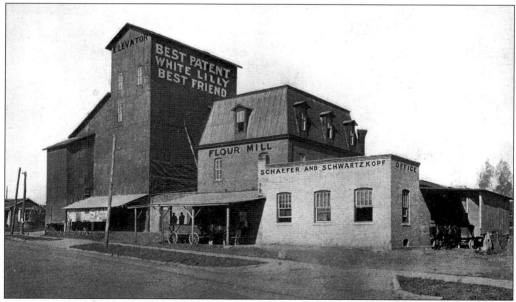

Charles Schaefer later sold his mill to his son John and son-in-law George Schwartzkopf. Continuing in operation until 1968 as Schaefer and Schwartzkopf, its products, such as "White Lilly" and "Schaefer's Best" flours were widely known. Cummins Engine Company purchased the site and the property became a parking lot. John Schaefer retired in 1943 and became a director of the Union Trust Company, which merged with Irwin's Bank to become Irwin Union Bank & Trust Company.

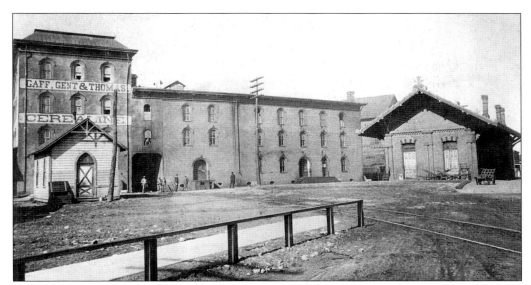

Located on the west side of Jackson Street between Sixth and Seventh Streets, the Gaff, Gent and Thomas mill did the biggest shipping business in town in the 1870s. It became the Cerealine Manufacturing Company and, according to the *History of Bartholomew County, Volume II*, quoting the *1879 Atlas*, "(It) was one of the greatest enterprises ever started in the county." After Cerealine moved to Indianapolis, the mill housed the Ben C. Thomas grain elevator and later Cummins Machine Works, a forerunner of Cummins Engine Company.

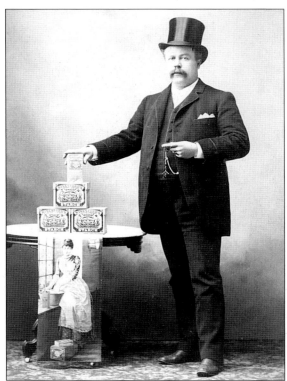

Kingsford Starch salesman Travis Schaeffer exemplifies the stereotype of the glib, dapper traveling salesman of the turn of the 20th century. Although starch was then heavily used in laundering shirts, collars, and shirtwaists, Schaeffer probably found few customers in Columbus. The American Starch Company at the northwest corner of Sixteenth and Washington Streets employed about 100 persons and sold its residual products, cattle and hog feed, throughout the world. The starch works burned in 1895.

A display at the Bartholomew County Historical Society demonstrates that the Lincoln Chair Company excelled in manufacturing both fine period furniture and utilitarian items for the home. It was started by the Rohminger brothers in 1890 as the Orinoco Furniture Company and sold two years later to a group headed by Harvey Lincoln. The Lincoln Chair Company went out of business in the 1930s.

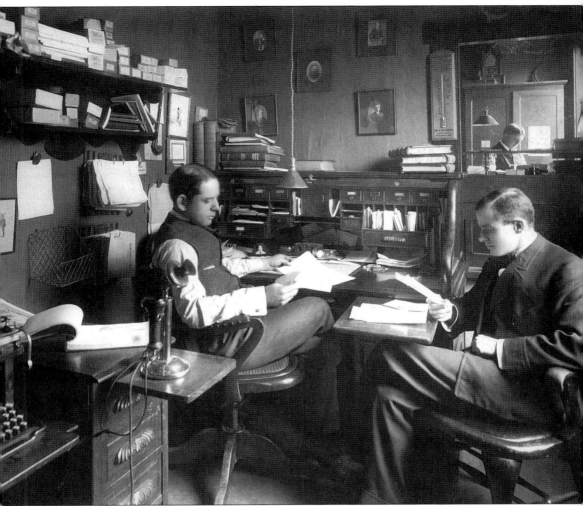

Luke Lincoln (left) and George Lucas (right) are believed to be the workers in this office of the Orinoco Furniture Building.

An exhibit at the Bartholomew County Historical Society displays products and resources of the Golden Foundry. With the rise of Cummins Engine Company in the 20th century, Golden Foundry forged the diesel company's heavy-duty engine blocks and cylinder heads and employed 600 people. In the 1990s, however, Cummins, faced with a need to curtail expenses, transferred much of that work to Mexico. In 2003, Golden Foundry closed its doors.

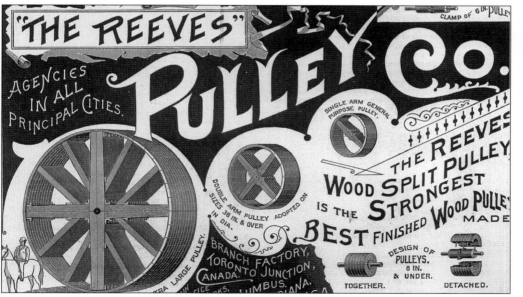

So widely known were their pulleys that Reeves & Company became known locally as "Reeves Pulley." First organized in 1875, the company excelled in manufacturing agricultural implements. Notable among these were the M.T. Reeves straw stacker, Hoosier Boy cultivator, and Reeves stalk cutter. Eventually, the company would occupy a 300,000 square-foot facility at 1225 Seventh Street.

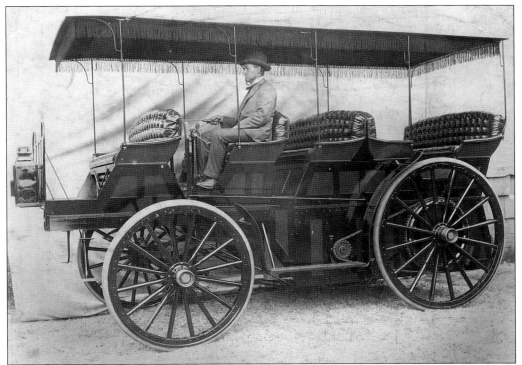

Reeves & Company also experimented with some pleasure vehicles. M.O. Reeves is at the wheel of a 20-passenger "bus" known as the "Big Motocycle." Built in 1898, it was shipped to Pierre, South Dakota, then returned to Columbus. After being refitted with railroad wheels, the vehicle traveled on the Big Four railroad to Hope, Indiana.

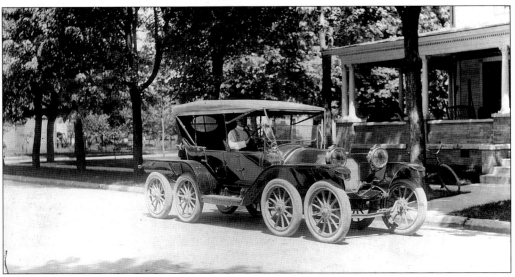

M.O. Reeves drives the Reeves Octomobile, so called because of its unique eight-wheeled design. Note the right-hand drive in contrast to the earlier "Big Motocycle," which the driver steered using a left-hand tiller.

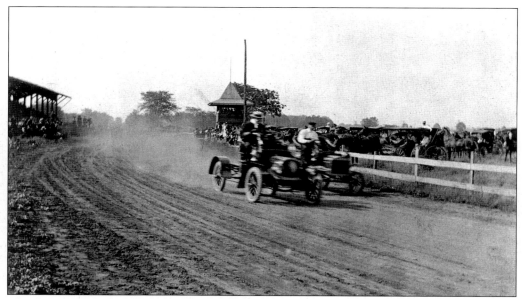

The first auto race in Columbus probably took place at the Crump Driving Park (later the Twenty-fifth Street Fairgrounds). G.L. Reeves (left) drives the 1906 Reeves Model Six. The landmark pagoda-like structure in the background may be the one that was preserved through local efforts and became a ticket booth at the 4-H Fairgrounds south of Columbus.

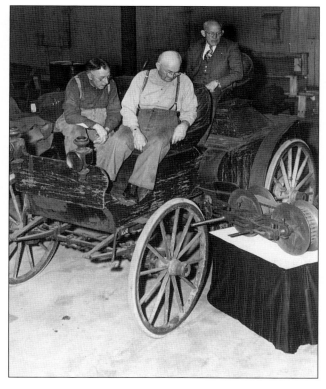

This early Reeves motocycle was retrieved c. 1950 from a barn where it had been stored for decades. Joe Reeves (left front), Bill Winn, and Charles Irwin (rear) inspect the original variable speed transmission in the foreground.

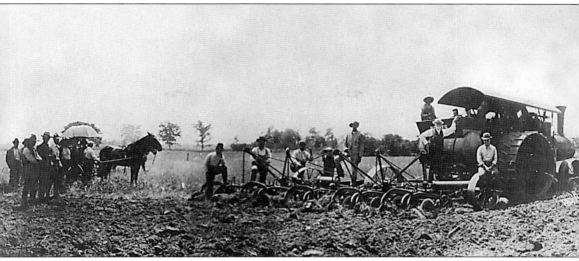

A Reeves steam tractor pulls a gang plow as farm workers and neighbors look on. F.T. Crump is the man with his hand on the back of the engine.

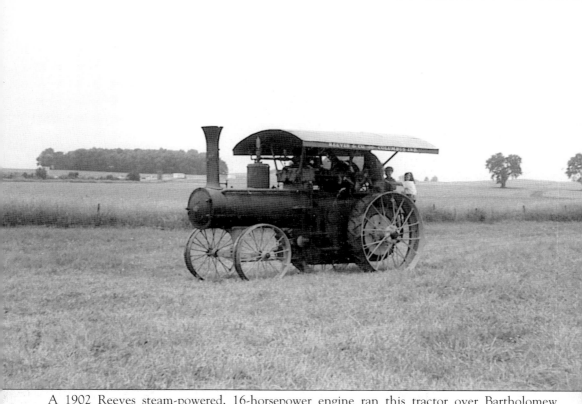

A 1902 Reeves steam-powered, 16-horsepower engine ran this tractor over Bartholomew County's fertile fields.

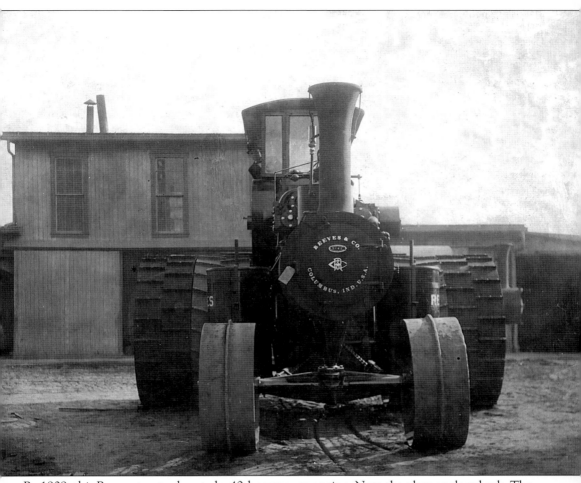

By 1909, this Reeves tractor boasted a 40-horsepower engine. Note the glass-enclosed cab. The Reeves & Company, Columbus, Indiana, USA trademark indicates the prestige this company enjoyed worldwide.

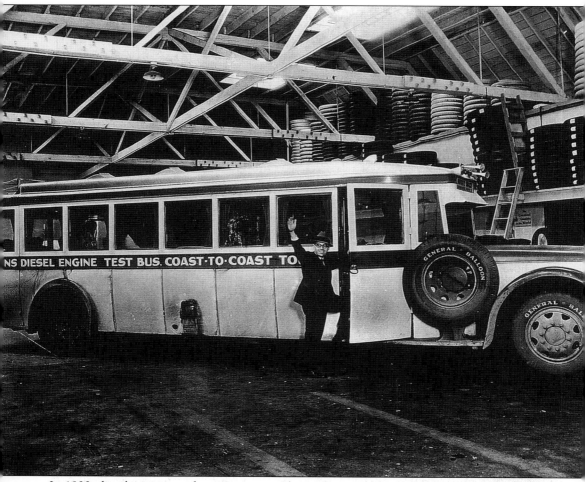

In 1932, diesel engine mechanic-inventor Clessie Cummins drove this 32-passenger Mack bus, powered by a 125-horsepower Cummins diesel engine, from New York to Los Angeles. Clessie set a transcontinental speed record, going 3,220 miles in a running time of just over 78 hours. The previous year he had driven a diesel-powered truck cross country on $11 worth of fuel.

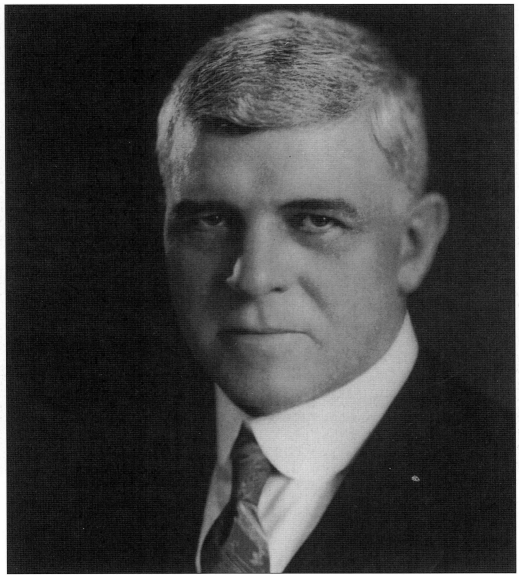

Banker William Glanton (W.G.) Irwin, son of Joseph Ireland Irwin, kept his faith and his financial backing in the ingenuity of diesel mechanic pioneer Clessie Cummins. In *The Engine That Could,* authors Jeffrey L. Cruikshank and David B. Sicilia state that this determination allowed the engine company to survive nearly two decades of losses. W.G. Irwin invested in a number of young companies; he would be known today as a "venture capitalist." He arranged the financing that brought Noblitt-Sparks Industries from Indianapolis to Columbus (later Arvin Industries, Inc., see page 54).

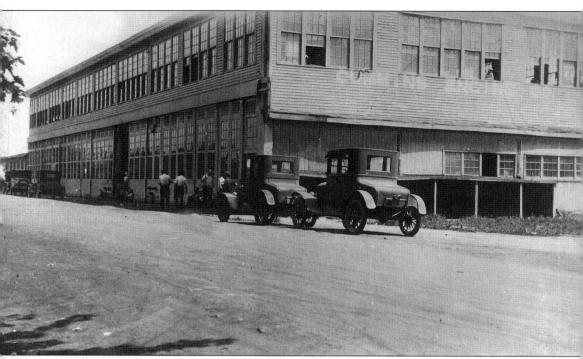

An early Cummins Engine Company (now Cummins, Inc.) plant was located on Central Avenue in the 1920s. Although the Irwin family supplied the capital for developing the engine company, today's Fortune 500 corporation still retains the name of Clessie Cummins, the family's chauffeur who experimented with and pioneered the diesel engine created by German inventor Rudolf Diesel in 1892.

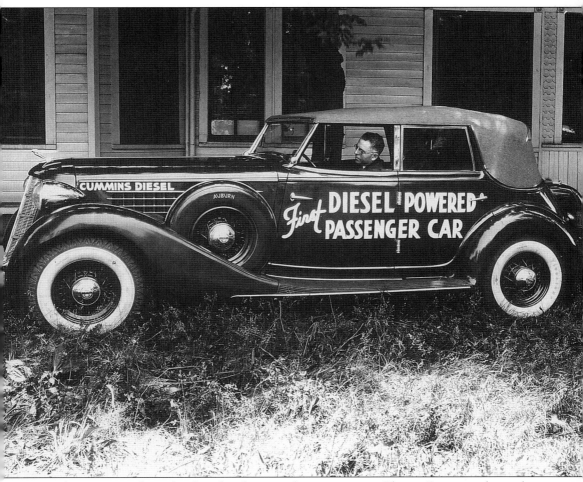

Several companies claim the first diesel-powered passenger car. Clessie Cummins drove this Cummins-powered Auburn from New York to San Francisco in 1935 on $7.62 worth of fuel, according to Cruikshank and Sicilia's research for *The Engine That Could.*

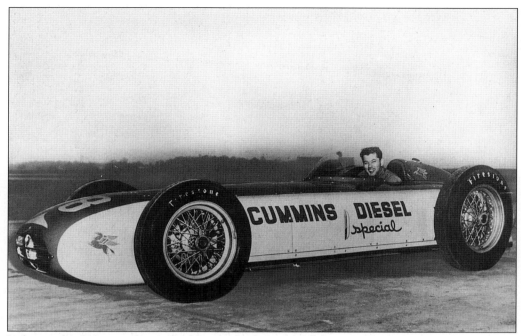

Indianapolis 500 race driver Freddie Agabashian of Albany, California sits at the wheel of Cummins' qualifier for the Indianapolis Speedway in 1952.

Q.G. Noblitt founded the Indianapolis Air Pump Company in 1919. Richard Arvin patented the car heater in 1920. By 1927, Noblitt's company began producing Arvin car heaters under the name Noblitt-Sparks, Inc. In 1950, the company became Arvin Industries, Inc. Q.G. Noblitt was not only a leading industrialist, but also an outstanding supporter of soil and water conservation in Columbus and Bartholomew County. He developed several residential areas in the county along man-made lakes and lagoons.

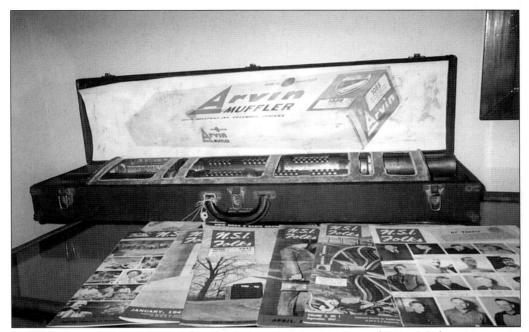

In 2000, Arvin Industries merged with Meritor Automotive, Inc. of Troy, Michigan to create ArvinMeritor, Inc. The corporation is a leading 7.5 billion-dollar global supplier to the auto and truck industry.

Although Arvin Industries was founded to manufacture automobile parts, the company produced car radios in 1933, home radios in 1934, and televisions starting in 1948. Manufacturing television sets under the Arvin name until 1955, the company then marketed some radio and television products under the Silvertone (Sears) name, until 1971.

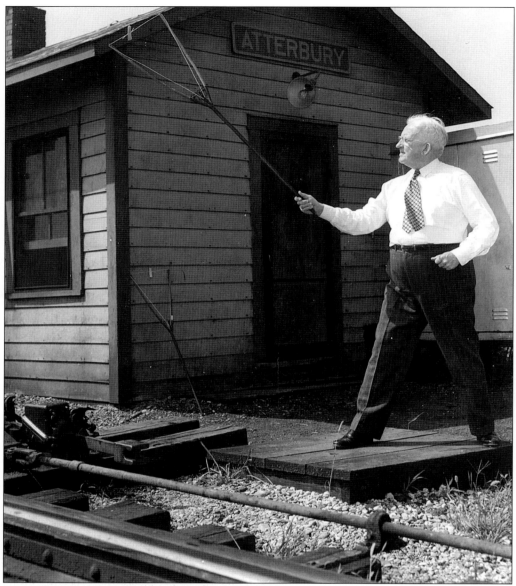

During World War II, nearby Camp Atterbury employed a number of Columbus area persons. More than 30,000 soldiers trained at Atterbury, and Columbus streets teemed with soldiers on weekend passes. Also, nearly 15,000 German and Italian prisoners of war were incarcerated there. Because of the wartime labor shortage, prisoners were frequently transported to work in area canneries and on surrounding farms during harvest time. One such employer was the canning factory run by Morgan Packing Company in Columbus.

Three

ARCHITECTURE

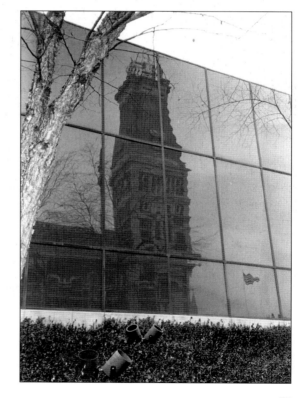

The glass-sheathed Commons of Cesar Pelli reflects the image of the majestic French Second Empire Bartholomew County Courthouse with its 154-foot clock tower. The two buildings symbolize the compatibility of time-honored structures in Columbus that exist alongside contemporary buildings by world-famous architects such as Eero and Eliel Saarinen, I.M. Pei, Harry Weese, Pelli, and others.

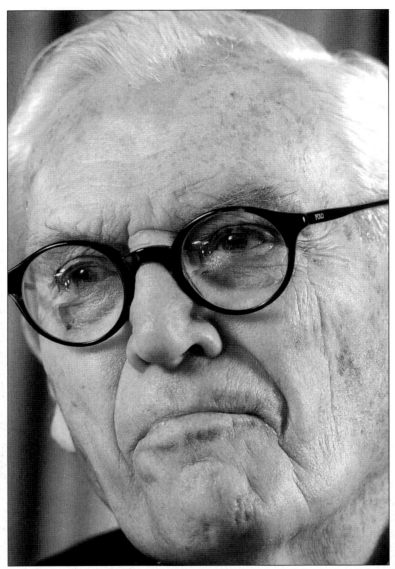

When J. Irwin Miller died on August 16, 2004 at age 95, the *Wall Street Journal* credited him as the single source for Columbus' "collection of contemporary buildings unrivaled by that of any other American city except New York, Chicago, and Los Angeles." Actually, while leading architects were wooed to Columbus by the largesse of Miller's Cummins Engine Company, the buildings they designed inspired private clients to strive for better architecture as well. J. Irwin Miller firmly believed in Winston Churchill's statement: "First we shape our buildings, then our buildings shape us." The Cummins Foundation, set up by Mr. Miller, then the engine company's board chairman, spawned for Columbus a commitment to excellence that would provide life-enhancing surroundings and facilities for its residents. A descendant of a revered minister and also of the founder of one of the city's earliest banks, Mr. Miller's interest in architecture started while he was a student at Yale and continued when he studied for a master's degree in classics at Oxford, England. The family home of Miller and his wife Xenia and their summer home in Canada are the only residences Eero Saarinen ever designed.

58

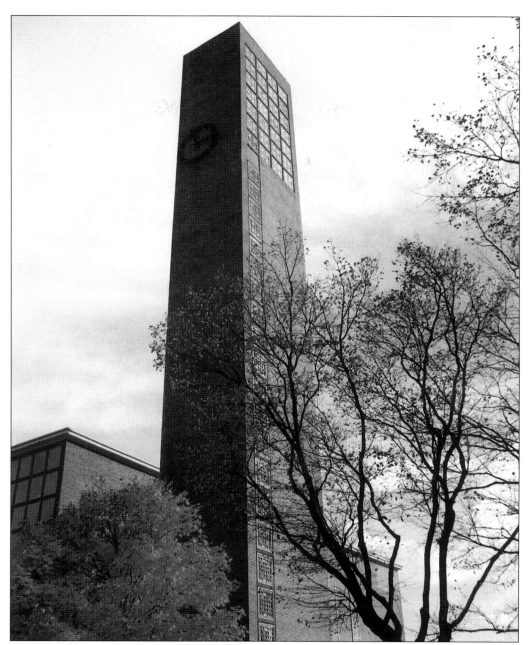

The pioneer model building that ushered in the architectural renaissance in 1942 in this small Midwestern city was the First Christian Church, located near downtown. J. Irwin Miller persuaded Finnish-born architect Eliel Saarinen to design this church for his family's congregation. The simplicity of the church's lines expressed "the congregation's emphasis upon the simplicity of New Testament faith," according to the *History of Bartholomew County, Volume II.* Approaching Columbus from the west, visitors can see the ornate Bartholomew County courthouse tower and the angular planes of this starkly modern church in juxtaposition in Columbus' skyline.

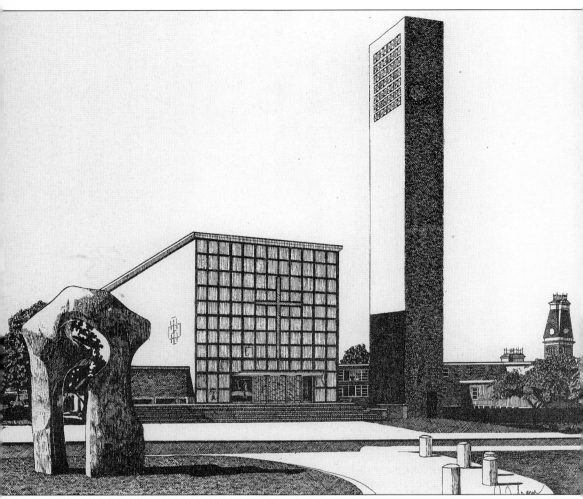

Former Columbus art educator Jonell Folsom created this pen and ink drawing of the First Christian Church, showing its near-downtown location. A large reflecting pool was originally part of the church landscape (at right), but maintenance was costly, and the pool has since been filled in and the area landscaped. The drawing is from a vantage point facing the church from the Cleo Rogers Memorial Library Plaza. Renowned sculptor Henry Moore's "Large Arch," at left, was commissioned by J. Irwin and Xenia Miller and was installed in 1971 at a cost of $75,000, according to a *Louisville Courier-Journal* report.

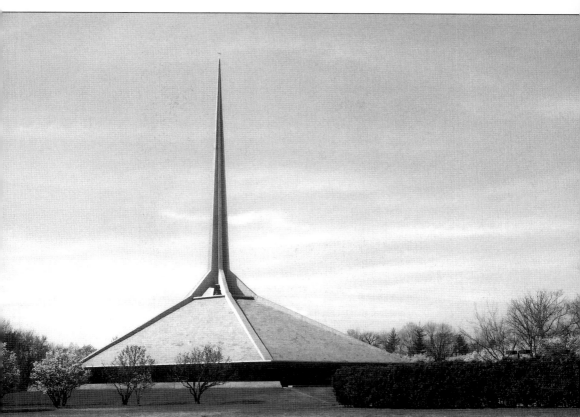

The spire of North Christian Church, built in 1963, rises from a hexagonal dome symbolizing the Star of David to acknowledge Christianity's Jewish roots. This was the last design executed by renowned architect Eero Saarinen, whose father's design had begun the architectural renaissance in Columbus (see page 59). Eero Saarinen died a few days after completing three years of work on the North Christian Church. He had said it was his best work because it had "a real spirit that speaks forth to all Christians as a witness to their faith." Inside, worshipers sit facing one another, surrounding the communion table. No one person is farther than 48 feet from the pulpit.

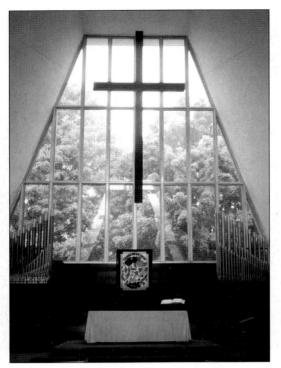

Local architects followed suit and began designing worship spaces that were more open and daring. This expansive windowed chancel inspires worshipers at Asbury United Methodist Church, built in the 1950s on the north side of Columbus. Architect was A. Dean Taylor, a member of the Asbury congregation.

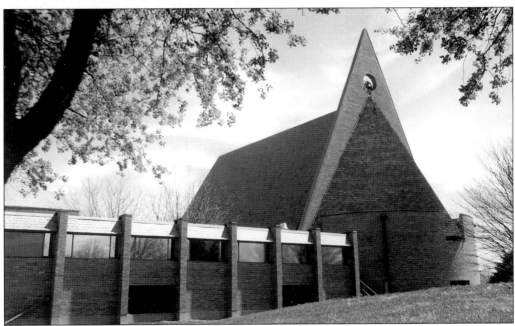

When the First Baptist Church relocated from its downtown church, built in 1855, to the Fairlawn residential area, members selected the architectural firm of Harry Weese of Chicago. The building of rose-colored brick with a sloping slate roof is reminiscent of a Norman castle, although its A-frame, natural wood interior presents a post-modern flair.

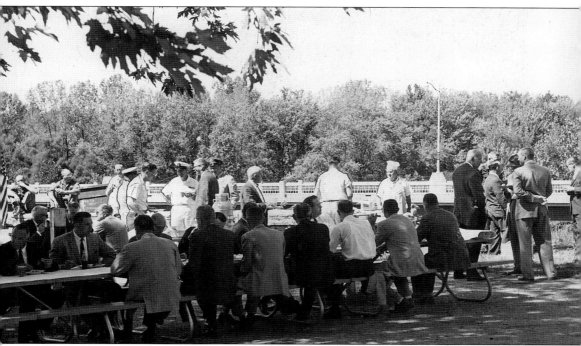

Active participation in planning by residents in the development of downtown has helped to keep the business district vibrant. From the *Evening Republican*, September 12, 1962, the caption reads: "Seated on benches in the old paved area that once was Second Street, members of the Downtown Development association eat under the shade of the trees in the new rest park site on the bank of the White River." Tipton Bridge is in the background. A monument to the city's founders is on the knoll out of sight and to the right.

Popular Bob Stewart was mayor of Columbus during much of the architectural renaissance. Both the mayor and his wife, Barbara, were innovators and supporters of the arts. Mrs. Stewart's dream of a festival of cultural diversity led to the Ethnic Expo, featuring ethnic food, crafts, and entertainment. It has been celebrated each year since 1984. Both Mr. and Mrs. Stewart received numerous awards for their support of the arts in Columbus.

CITY - COUNTY PLANNING ...

- Assist in Establishing Minimum Standards.

- Encourage Orderly Annexation With Extension Of City Services.

- Work With Professional Planner For Master Planning Of Metropolitan Area, Streets, And Thoroughfares.

- Promote Development Of City's Growth To the West And Southwest.

This 1962 agenda for city-county planning indicates the foresight of community leaders into future needs involving not only the town of Columbus but also the entire county.

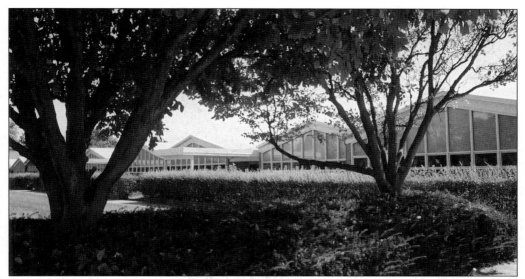

Built in 1957, Lillian C. Schmitt Elementary School bears the name of a first grade Columbus teacher who taught for 43 years. This was the first school designed by a participating architect in Cummins Engine Foundation's architectural program. The design by Harry Weese of Chicago provided an interesting zigzag roofline and a hexagonal interior multipurpose room. Extensive landscaping complemented the exterior of all of the schools that would be designed through the architectural program.

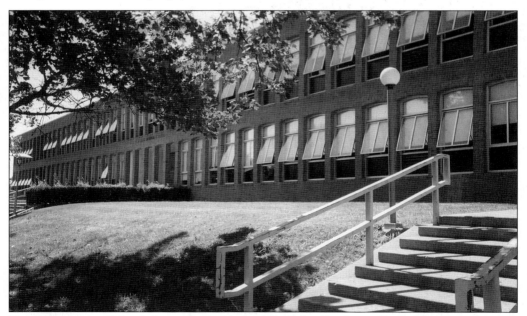

Northside Junior School (now Northside Middle School), also a Harry Weese design, was completed in 1961. The tri-level structure features uniform rows of arched windows. Northside, Lillian C. Schmitt School, Columbus North High School, and the administration building for the Bartholomew Consolidated School Corporation are all located adjacent to one another in the vicinity of Twenty-seventh Street, Home Avenue, and Maple Street.

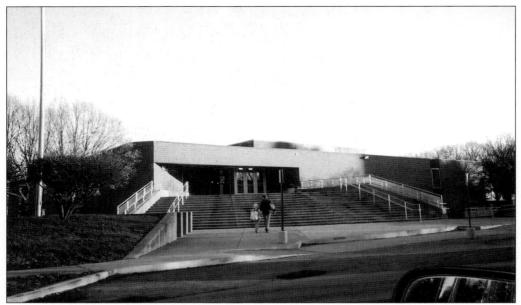

Lincoln Elementary School, near downtown Columbus, opened in 1965. Gunnar Birkerts and Associates of Birmingham, Michigan were the architects. In 1967, First Lady "Lady Bird" Johnson toured the school when she visited Columbus to recognize the community's architectural program. A plaque she unveiled at the school commemorates her visit and her contributions to the awareness "of beauty and culture throughout the country."

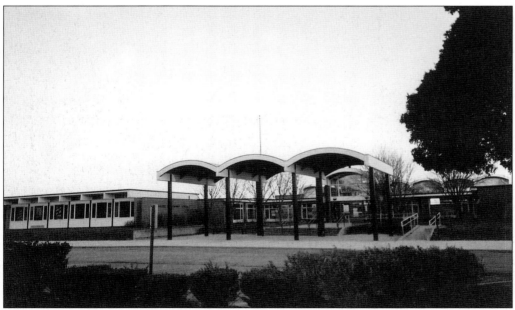

Norman Fletcher of The Architects Collaborative, Inc. of Boston was principal architect for Parkside Elementary School. Opened in 1962, Parkside was situated on a six-acre tract just south of the Columbus Municipal Airport. The vaulted-roof structure would serve the neighborhoods that were expanding rapidly to the north of town.

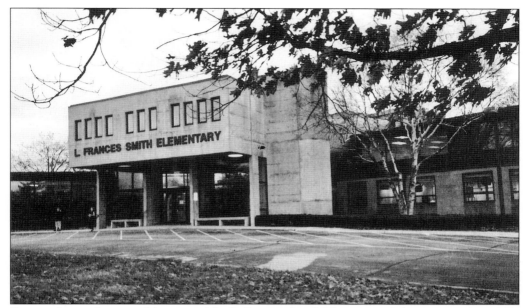

Outstanding architectural features of the L. Frances Smith Elementary School, opened in 1969, were the playful, brightly colored ramps or "tubes" connecting the building's three levels. The 20-room building, named in honor of an elementary education supervisor who served for 24 years, was the design of John M. Johansen.

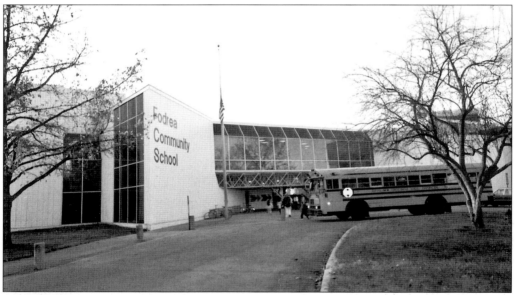

Fodrea Community School has earned several national awards for its design and construction. Architects Paul Kennon and Truit Garrison for Caudill Rowlett Scott included a landscaped courtyard in this open-classroom style school. The bell and cornerstone from the State Street School that it replaced were moved to the new school. Fodrea School bears the family name of three sisters, Hazel and Bessie Fodrea and Mabel Fodrea Jordan, whose combined teaching service to Bartholomew County Schools totals more than 80 years.

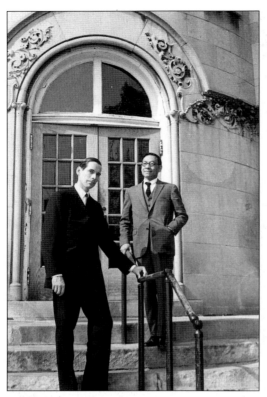

World-famous architect I.M. Pei and associate Kenneth D.B. Carruthers of New York City stand on the steps of the Columbus Public Library, built in 1899. They are looking over the proposed site for what would be the new Cleo Rogers Memorial Library. This photo appeared in the October 24, 1963, *Evening Republican*. The new library would be named for Miss Cleo Rogers (1905–1964), county librarian for 28 years and assistant librarian for nine previous years. An $800,000 grant from Cummins Engine Foundation helped to finance construction.

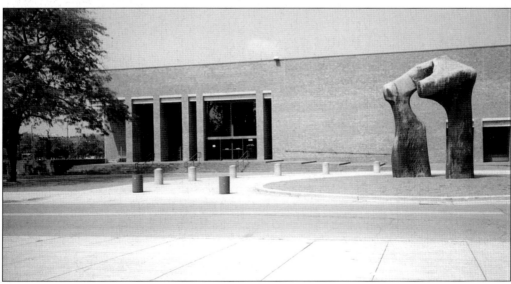

Completed in 1969, the Cleo Rogers Memorial Library and the Library Plaza have become a center for community cultural activities. At the architect's suggestion, Lafayette Avenue between Fifth and Sixth Streets was closed to create the desired urban space. Thus, the library and the plaza are bordered by the Irwin Home on the east, the First Christian Church to the south, and the old city hall (now Columbus Inn) on the west.

For more than 130 years, Columbus and Bartholomew County have treasured and cared for the courthouse, making renovations and repairs in 1928, 1953, and 1969. When estimates to replace the court house ran over 6 million dollars in 1967, preservation and extensive restoration and renovation began. Listed on the National Register of Historic Places, the court house was selected for the cover image of a recent book picturing Indiana's 92 county courthouses.

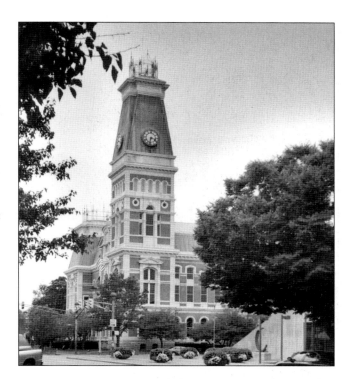

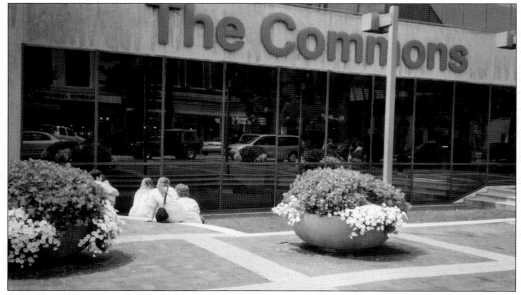

Initially called Courthouse Center when it opened in 1973, The Commons was designed by Cesar Pelli as a downtown "superblock." With Sears as its major retail tenant, The Commons houses some 20 smaller shops, including The Viewpoint, an independent bookstore that offers "national content with a local perspective." Other Commons' features are an innovative children's playground, a children's museum, and an art gallery. Concerts and dances take place in a spacious open area.

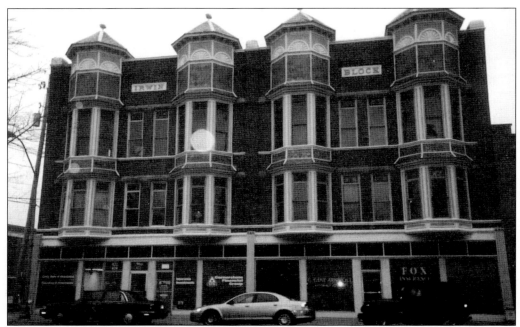

Owners of the Irwin Block on Fifth Street between Washington and Franklin Streets have restored the stained glass panels in the upper fourth of the bay windows and duplicated the original Victorian-style color scheme. In a 1980s revitalization effort of the Historic District, more than 80 percent of the downtown storefronts were renovated.

Each year, approximately 50,000 visitors, including architectural students from several universities, visit Columbus. The Visitors Center provides tour guides, who are trained volunteers, for these groups.

Another Harry Weese design is the Otter Creek Clubhouse, overlooking the 18-hole Otter Creek Golf Course, designed by Robert Trent Jones, four miles east of Columbus. Cummins Engine Company gifted the clubhouse and golf course, completed in 1964, to the City of Columbus. At the dedication, J. Irwin Miller, then chairman of the board of Cummins Engine Company, Inc., stated that Cummins was "happy to pay our share" to help make Columbus the very best community of its size in the country.

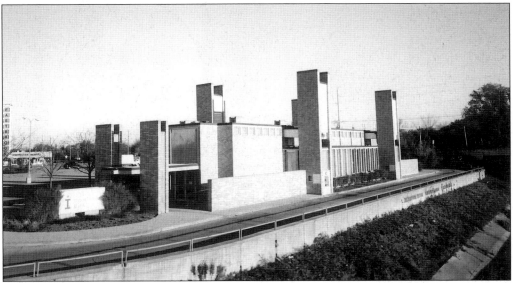

Townspeople sometimes called it "The Dead Horse" when the Irwin Union Bank Eastbrook Plaza branch was built in 1961. Eventually, the four towers that housed the heating and cooling units became an everyday sight, and residents in the 1960s and 1970s would become accustomed to even more innovative architectural structures. The bank is at National Road (U.S. 31) and Twenty-fifth Street. The architect was Harry Weese.

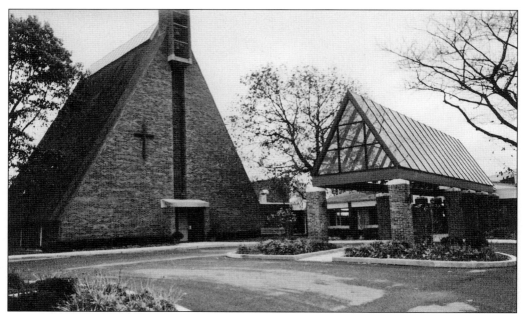

The Four Seasons Retirement Center, designed by Norman Fletcher of the Architects Collaborative is home to many longtime Columbus residents who wish to stay connected to their town.

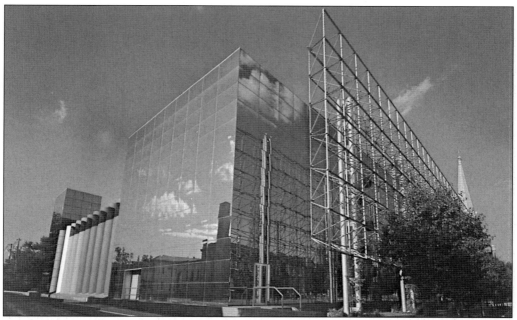

Winner of an American Institute of Architects (AIA) award in 1980, the Indiana Bell Switching Center's reflecting glass "skin" mirrors the neighborhood, not appearing to be a building at all. Designed by the Rowlett Scott firm of Houston, the structure's brightly colored silo-like towers contain heating and air conditioning units. They are often playfully referred to as "organ pipes."

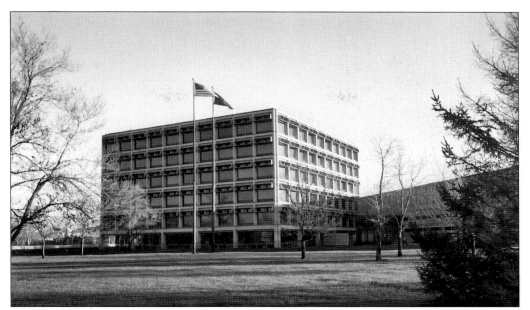

Plantings and pools designed by landscape architect Dan Kiley of Charlotte, Vermont, surround Cummins Technical Center. The facility, designed by Harry Weese of Chicago, was completed in 1968. Rows of London plane trees line both sides of Central Avenue, linking the tech center visually to other Cummins Engine facilities on the opposite side of Haw Creek.

This modest frame cottage at 1310 Franklin Street is typical of many "carpenter's cottages" built near downtown Columbus in the late 19th century. This one had been converted into two apartments. A local group, Preserve to Enjoy, Inc. purchased it in 1981 and restored it to its original design.

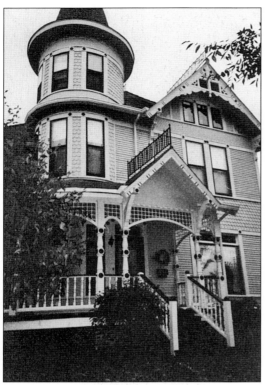

Typical Queen Anne-style, with its wrap-around, carpenter lace-trimmed porch, the Prall House at Fifth and Lafayette Streets stands in stark contrast to the Cleo Rogers Memorial Library and Plaza that it faces. Dr. Will J. Prall built the house c. 1895 and had his dentist office on the Lafayette Street side. Mrs. Clementine Miller Tangeman bought the home in 1986 and renovated it into two apartments, but restored the original exterior appearance.

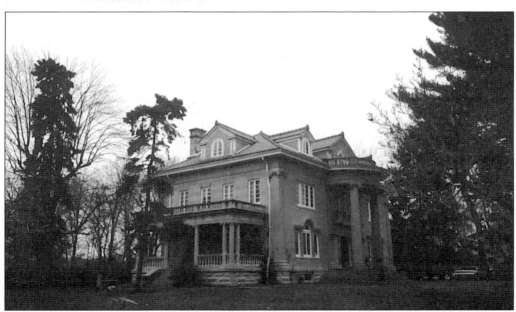

Built c. 1910–1914 by W.W. and Lydia Newsom Lambert, both descendants of pioneer families, this stone mansion at 1910 Washington Street eventually became the home of Arvin president Q.G. Noblitt and his wife Grace. The Doric columns support a two-story portico entrance with a balcony over the doorway. Doors on the south side open to a pillared veranda.

Renewed interest in the history of older homes in Columbus has brought about efforts to duplicate elements of the courtyards of a bygone era. Notice the serpentine brick paving.

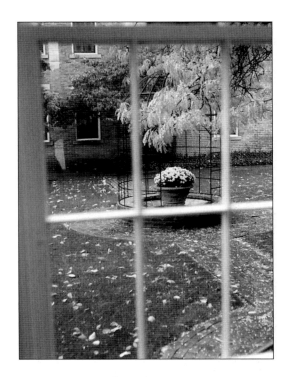

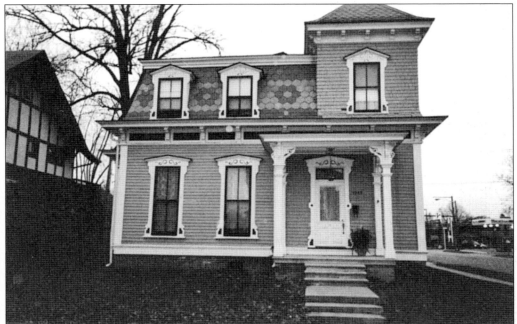

This home at the corner of Tenth and Franklin Streets is one of the city's few Second Empire structures. The mansard roof and patterned roof give it a distinctive appearance. The home has had many occupants through the years, but in 1992, Mr. and Mrs. Fred Meyer renovated it completely as an investment property.

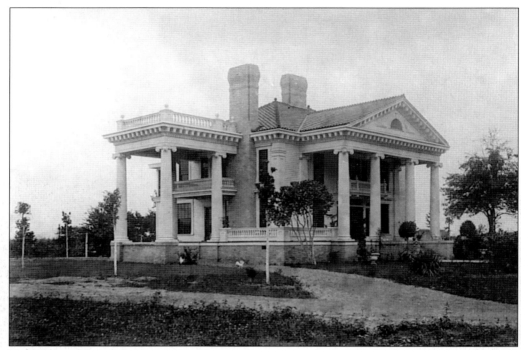

Not all the elaborate homes in Barthlomew County were built in Columbus. This one belonged to William Mode Graves who lived from 1829 to 1903. He built this mansion near Hartsville, a few miles east of town.

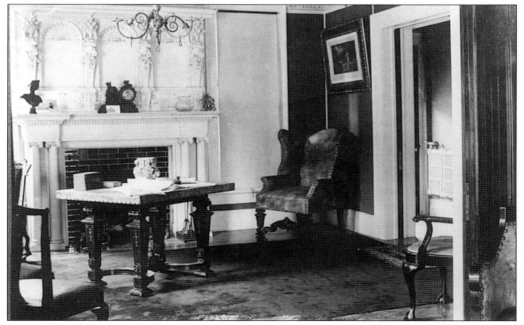

The parlor of the Graves' home featured Grecian-style cornices and an elaborate fresco over the fireplace.

Inspired by Thomas Jefferson's Monticello and the villas and gardens of Italy, Elsie Irwin Sweeney built this 12-room, U-shaped mansion when she was 75 years old. "Miss Elsie," aunt of J. Irwin Miller and Clementine Miller Tangeman, was a philanthropist and patroness of the arts. She opened this home, named Castalia from Greek mythology, for many worthy causes. Indianapolis architect Thomas C. Dorste surrounded the mansion on three sides with a small man-made lake. Tile and wrought-iron work were brought from Italy to decorate the home, and rocks and glacial boulders from Canada surround the spring and waterfall in the landscape. Since Miss Elsie's death in 1972, Castalia has had several owners and has been used as a family home, a corporate retreat and conference center, and a vacation home.

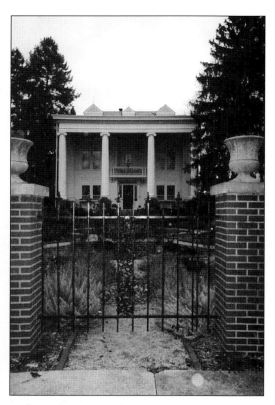

This frame mansion stands at 1210 Sixteenth Street. William and Martha Crump Ruddick built it in 1885 on 80 acres of land Martha inherited from her father, Francis Jefferson Crump. Originally, it was painted bright yellow. Reportedly, it had the first full bathroom in town. The oak center stairway was inlaid with cherry, and the home had 11 fireplaces. Owners in the 1970s, Roy and Jean Medaris, undertook careful restoration. In the late 1990s, new owners Dennis and Joyce Orwin opened the home as a bed and breakfast.

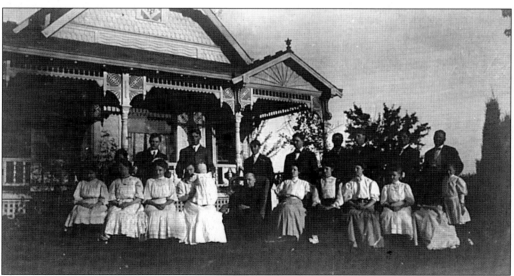

This Parker family reunion, near the turn of the century, may have taken place at the free-classic home at 624 Lafayette Avenue. According to the *Bartholomew County History Volume II*, the William Eddy Parker family purchased this home around that time. The notation on the photo says that "Mina" is on the far right. Perhaps this is Mina Morris Scott, who became known for her poetry in later years.

Four

RESTORATION
AND RECYCLING

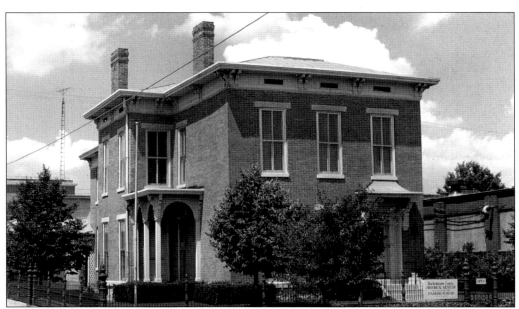

The headquarters of the Bartholomew County Historical Society was once the handsome Italianate home of three different prominent Columbus families—the McEwens, the Samuels, and the Marrs. After James Marr died in 1914, it became a rooming house, then apartments. The Bartholomew County Historical Society found this home could be restored to suit its needs. Certain elements of grandeur remained intact, such as the elegant entrance, the winding staircase, and the iron fence around the front.

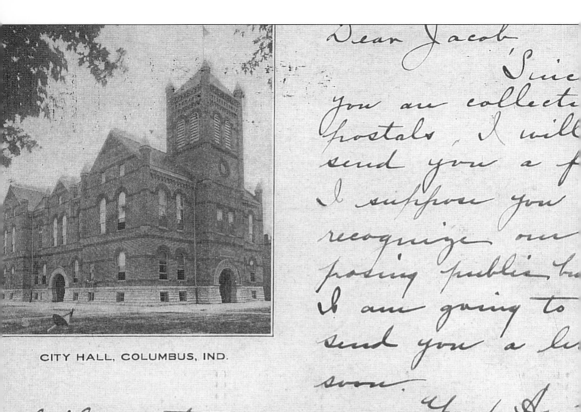

CITY HALL, COLUMBUS, IND.

Dear Jacob,
Since you are collecti[ng] postals, I will send you a f[ew]. I suppose you recognize our posing public bu[ilding] I am going to send you a le[tter] soon.
Your Aun[t]

[A]pril 15th 1906

The first Columbus City Hall was completed in 1895 on the southwest corner of Fifth and Franklin Streets. The site had been sadly vacant for about two years since the fire that destroyed the Gaff, Gent, and Thomas Mill around 1893. Charles F. Sparrell, architect of many Columbus structures, designed the Romanesque Revival brick and limestone building. In addition to city offices, it contained a banquet hall, a dance hall, a basketball court, and an exhibit area. In the basement, a farmers' marketplace opened to the public on the west side of the building. The writer of this "postal" reflects the pride Columbus residents felt in their imposing new city hall. It became a center of community activity, housing Columbus High School basketball games, Columbus Symphony Orchestra rehearsals, and service club meetings. During World War II, it offered hospitality to soldiers from nearby Camp Atterbury. A billiard room was located on the west end, and a large meeting room was accessed through French doors, also on the west. The Columbus Public Library, organized in 1899, was housed in the city hall for the first few years.

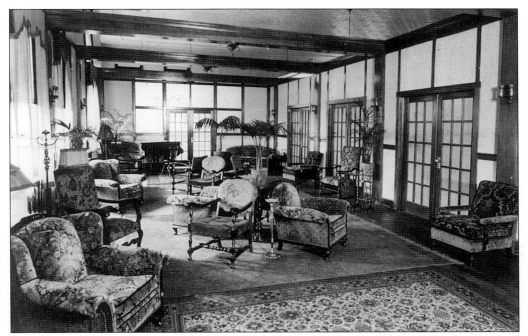

The lounge belonging to the chamber of commerce on the second floor of the first city hall reflects the style of furnishing typical of the 1890s. The kitchen also occupied the second floor, and caterers used the fire escape to access it.

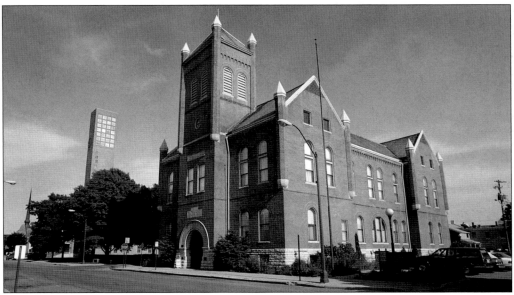

Need grew by the 1960s for larger facilities for city government. After the community debated the city hall's future for several years, Cummins Engine Company purchased it in 1980. The National Register of Historic Places had listed it in 1979. The city council passed a resolution to finance the building's renovation and conversion to a bed-and-breakfast facility that would combine modern facilities with the elegance of bygone days. The Columbus Inn opened in 1986.

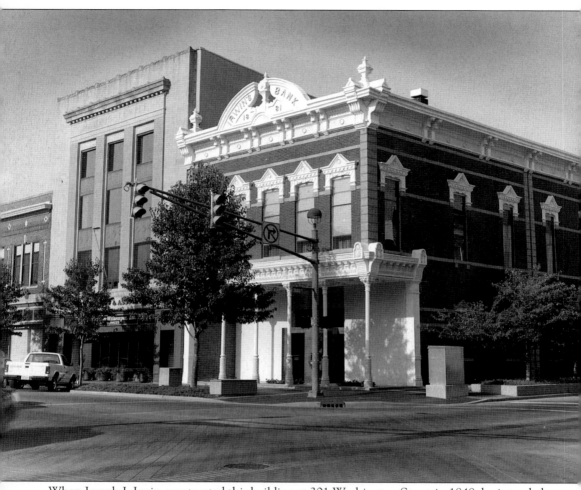

When Joseph I. Irwin constructed this building at 301 Washington Street in 1848, he intended to use it as his bank with his dry goods store on the Third Street side. By 1895, he had expanded his banking interest and remodeled the entire building for his bank. In 1966, the exterior of the building was reinforced and the interior completely rebuilt. Alexander Girard of Santa Fe designed this renovation. The building was restored to its 19th-century elegance, yet it houses an eclectic collection of contemporary art and collectibles as well as family portraits. It is the headquarters for the Irwin Management Company, Inc. and the Irwin-Sweeney-Miller Foundation.

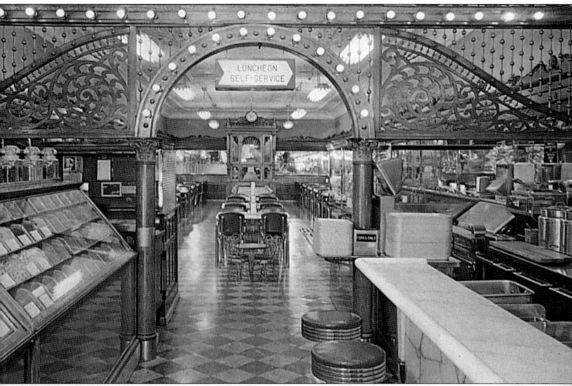

The Zaharako family has operated a confectionery at 329 Washington Street since 1900. A latticework archway at the rear opens to a large seating area with mirrored walls. At the very back stands the 185-pipe M. Weste Orchestrion, made in Freiburg, Germany and purchased in 1908.

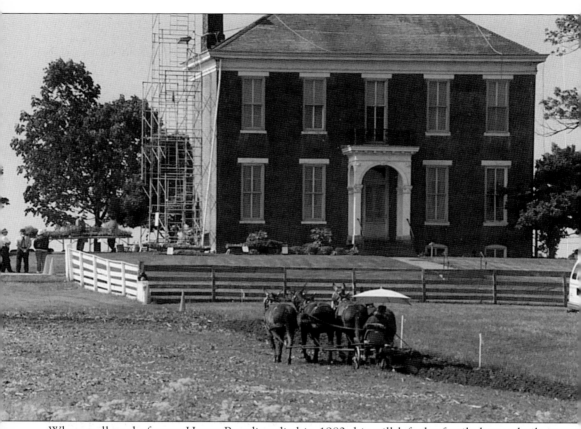

When well-to-do farmer Henry Breeding died in 1982, his will left the family home, built in 1871, to the Bartholomew County Historical Society. The residence, located north of town near Interstate 65, typified the lifestyle of affluent landowners in the county's earlier eras. Visitors may tour the home, and the large barn now accommodates square dances, wedding receptions, and conferences and exhibits. Demonstrations of farming in earlier days sometimes take place. The mules in this photo belonged to Darrell Jessie.

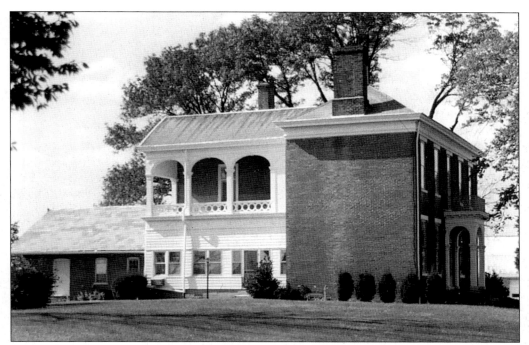

The first floor of the side porch or gallery of the Breeding home had been enclosed as a sunroom in the 1930s. The upper level was also enclosed at an earlier date, but is shown here as it is now restored to its original purpose.

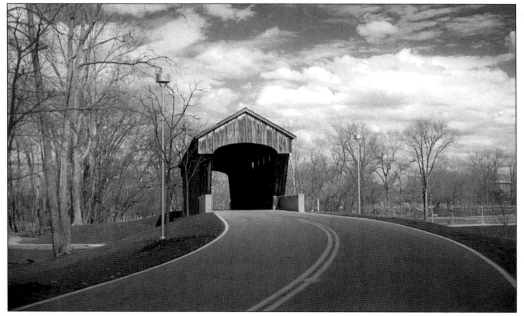

In the 1960s, community efforts to save a covered bridge in Bartholomew County led to its relocation in Columbus' near-downtown Mill Race Park. Although fire later destroyed the original bridge, a replacement now stands as a reminder of travel in the past.

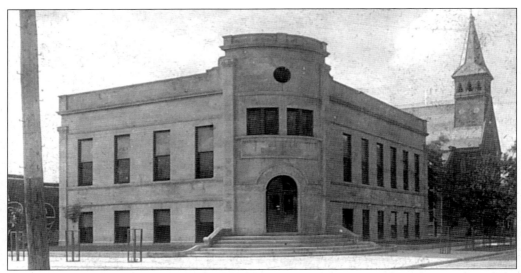

Not all buildings were found suitable for restoring or converting to another purpose. The original Columbus Public Library, built of Indiana limestone in 1903, had outlived its usefulness by the 1960s. Built at Fifth and Mechanics (Lafayette) Streets, the Carnegie-financed facility had been the pride of Columbus when it opened. Many residents recall the limestone threshold that became deeply worn by thousands of feet. This 1904 photo shows the library's proximity to the Tabernacle Christian Church, forerunner of the First Christian Church.

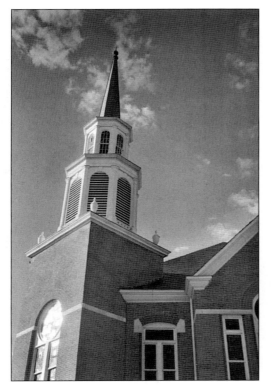

The spire of the First United Methodist Church soars to meet the blue of a summer sky. Designed by Charles F. Sparrell, the church (originally Methodist Episcopal) has stood at Eighth and Lafayette Streets since 1887. This spire replaced the original Romanesque tower, probably at the time of a 1930 renovation. The organ was a gift of the Goldens of Golden Foundry in 1952. In the 1960s, the church was remodeled in the Williamsburg design.

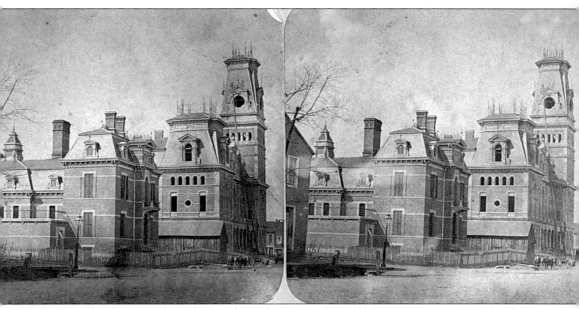

People of Columbus must have had pride in their court house before it was even completed in 1874. This stereopticon view shows the building before the windows were installed.

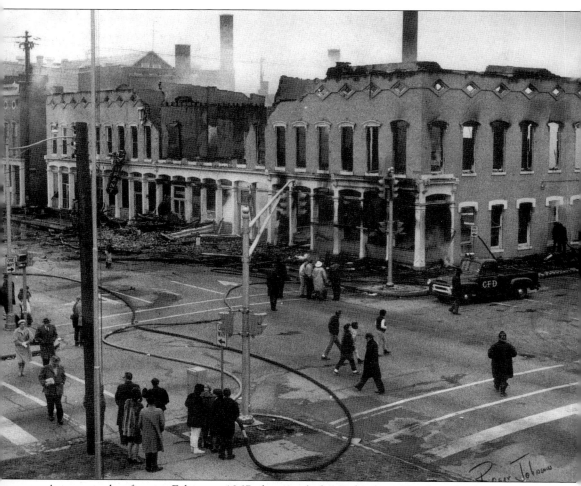

A spectacular fire in February 1967 destroyed the Belvedere Hotel and adjoining Gause restaurant at Third and Franklin Streets. Although the two-story structure burned to the ground, there were only a few minor injuries. A three-story hotel, the Surrey Inn, was built on the site by the Suhre family.

In 1978, the Surrey Inn was sold to the county and the structure renovated as an annex to the county courthouse.

In 1983, Cummins Engine Company built its corporate headquarters a stone's throw from the town's business district. Architects Roche Dinkeloo and Associates preserved the four-story brick Cerealine building as an integral part of the complex. Its rebuilt interior includes three floors of conference and meeting rooms and an employee dining room overlooking a reflecting pool and landscaped grounds. The pink brick exterior of the former mill and its tall shape accent the office building's low, limestone profile.

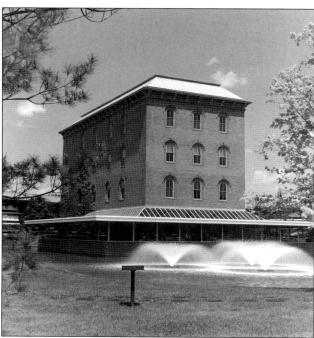

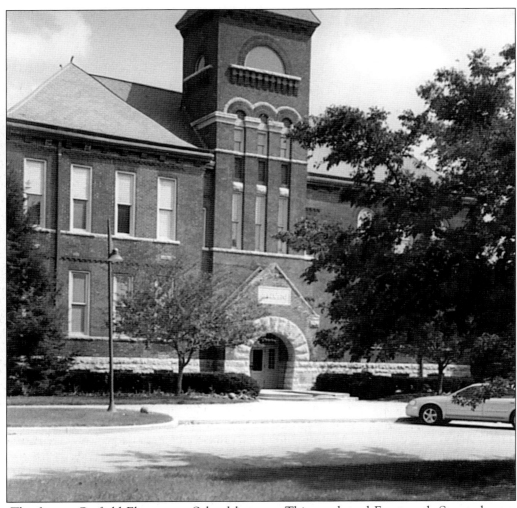

The former Garfield Elementary School between Thirteenth and Fourteenth Streets houses offices of ArvinMeritor, Inc., formerly Arvin Industries, Inc. The corporation purchased 15 houses surrounding the school and razed them, creating the open space between the existing Arvin plants and what would then be the corporate office building. Completed in 1989, the complex became a dramatic statement of history and tradition. Said William Browne, Jr. of Ratio Architects, Inc., "The aim was to preserve the existing schoolhouse . . . while adding new construction to define and balance the historic flavor of the structure." An addition that quadrupled the size of the original school building blends compatibly with the 93-year-old structure. Note that the arched main entrance and the three-story tower above it remain; these were "signature" elements of designs by Charles F. Sparrell, the original architect (see pages 86 and 91). A synthetic slate roof replaced the original slate roof and also covered the 27,000-square-foot expansion. Designers incorporated landscaping as an integral element of construction. A waterfall, pools, grassy mounds, brick walkways and streets, benches, and limestone walls complement the spacious campus.

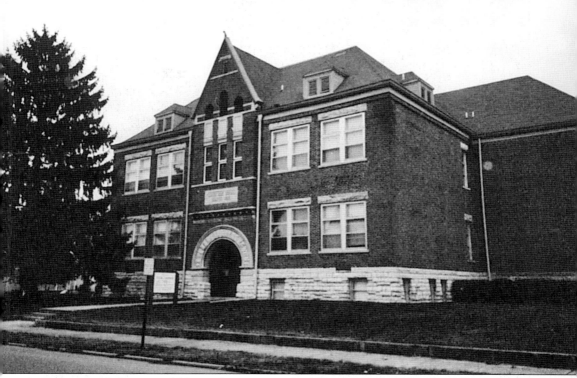

At Seventeenth Street and Home Avenue, another Charles Sparrell building, formerly the 1892 Northside School (later renamed McKinley in honor of the assassinated United States president) has taken on new life as a 20-unit apartment building. Closed since 1981, the school's transformation was completed in 1988. Architects were Richard and Jan Sprague and Gary and Mona Wirth. The exterior remained the same, and inside tall windows and 12-foot ceilings became sought-after features in some units. The McKinley apartment building was judged the best "tax-act rehabilitation project for residential use" by the Indiana Division of Historic Preservation and Archaeology in 1989. It is listed in the National Register of Historic Places.

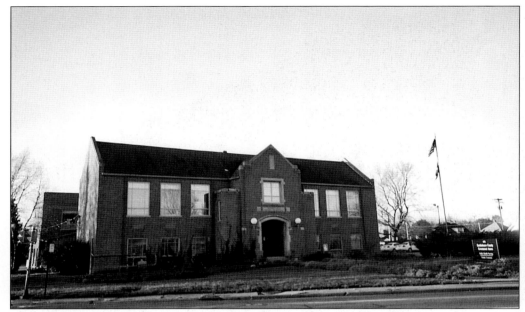

When the Fodrea Elementary School replaced this building on State Street, a new life emerged for the old facility. After extensive renovation, it now houses the Bartholomew County Extension Service.

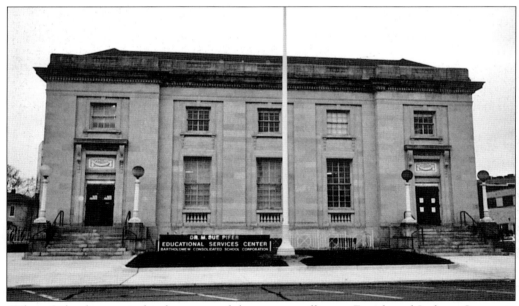

When Columbus opened a then state-of-the-art post office on Fourth and Jackson Streets in 1970, the Bartholomew County School Corporation purchased its limestone predecessor at Seventh and Franklin Streets. The former post office building is now the educational services center for the Columbus schools.

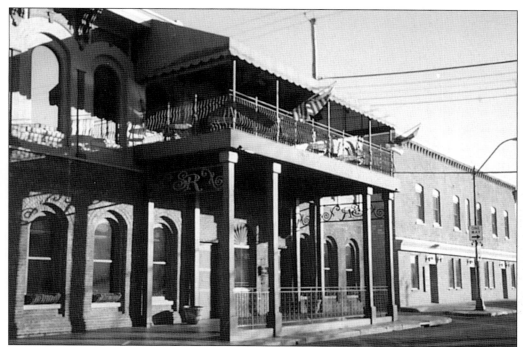

The iron railings and balcony reflect the history of this building now known as Smith's Row, an upscale restaurant on Fourth Street. Originally, it housed a blacksmith's shop.

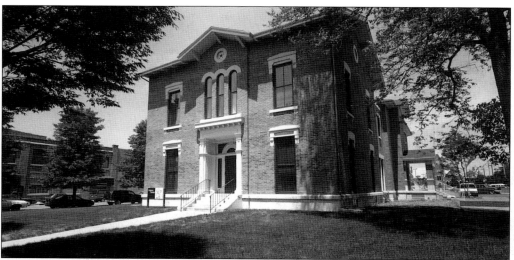

Before it became the Columbus Visitors Center in 1973, the Storey House housed the Columbus Boys Club for a number of years. The property had also been home to a dentist's office, a lodge hall, and a newspaper accounting office. Leading Columbus businessman John Storey (see page 37) built the Civil War-era home using native wood and limestone. Extensive renovation and adaptation of the structure for the Visitors Center was funded by the Irwin-Sweeney-Miller Foundation (ISM), and the foundation's director, Xenia Miller (Mrs. J. Irwin Miller), directed the renovation.

A 1965 model block plan initiated by the city, working with Alexander Girard, noted architect and planner, had a decided impact on the downtown area. Storefronts were renovated, signage improved or minimized, and lighting added. Eventually, about 80 percent of the downtown merchants followed suit and continue the upkeep. Note the shade trees, planted in the 1960s, that create a boulevard effect on Washington Street.

The spirit of renovation and restoration in Columbus may serve to inspire owners of smaller, solidly built 20th-century houses to retain their interest in them and help them appreciate in value. This Prairie-style house is a good example of one that is being kept in good repair.

This building at the southwest corner of Seventh and Franklin Streets has seen three lives. Originally built as an Indiana National Guard Armory, it later became home to Indiana Vocational Technical College (Ivy Tech). When the school outgrew the building and moved to a new facility in 1983 at the former Bakalar Air Base, the building was converted to apartments for senior citizens.

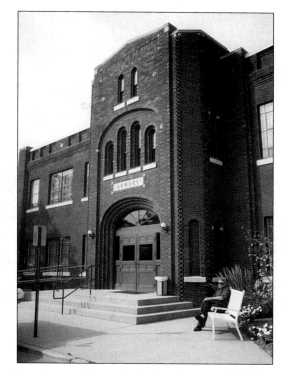

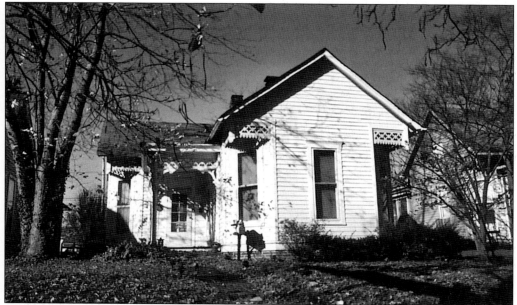

Typical of many modest frame cottages built near the turn of the 20th century, this home, still in use, has a small side porch and carpenter lace trim. Factory owners built a number of similar homes to encourage workers to move their families from farms and work in their factories. A non-profit organization, Preserve to Enjoy, Inc., formed in 1977, renovated several of these homes by means of private funds.

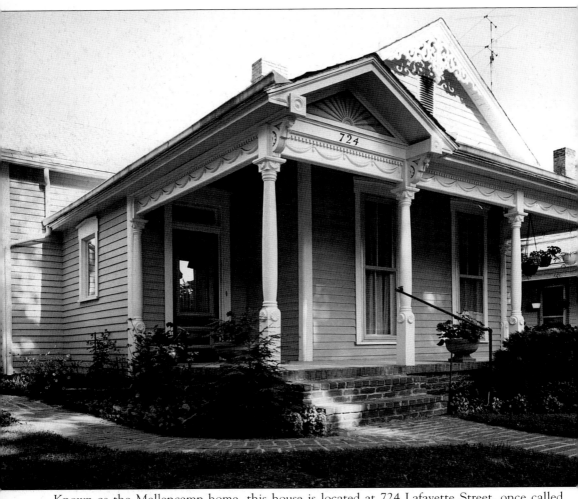

Known as the Mellencamp home, this house is located at 724 Lafayette Street, once called Mechanics Street. Excellent examples of cottages that have been renovated and recycled can be seen on this street.

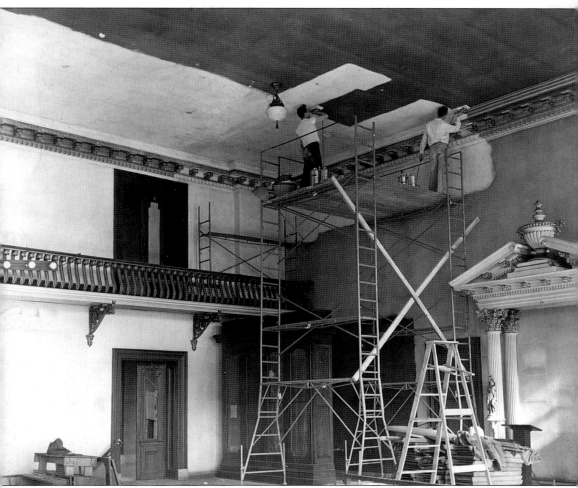

"Yes, that's the court house, all right," said an enthusiastic Mary Ellen Sweet Grossman. Ms. Grossman, genealogist in the county clerk's office, verified this photo as restoration activity in progress during the 1960s renovation of the Bartholomew County Court House. Originally, this courtroom, Superior Court I, was the only courtroom in the county. One of the remarkable alterations was lowering the ceiling of the courtroom to provide a meeting room on the third floor for county commissioners and council.

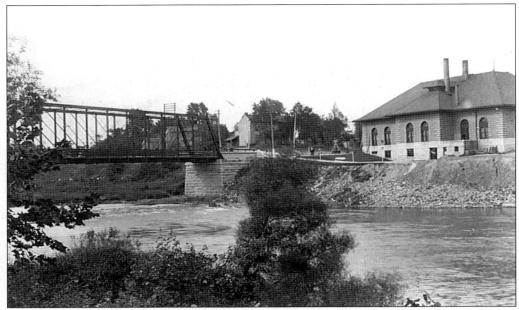

The Columbus Power House stood on the bank above the east fork of the White River at the foot of Second Street. Built in 1903, it produced electricity for city street lighting as well as housing a water pumping station. By 1952, the Power House was no longer needed because of a new system of deep wells. Southern Machine Company purchased the building and sold it in 1972 to the Columbus Redevelopment Commission.

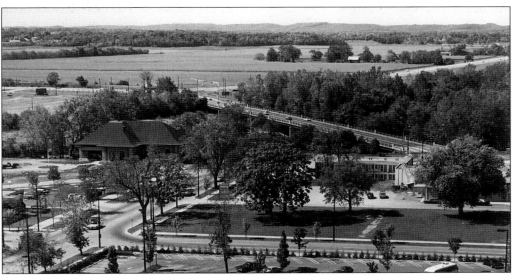

Today, the Power House has taken on a new identity as a well-used senior citizens' center. Renovation was accomplished using $390,000 in community development funds from the Department of Housing and Urban Development. Dedication of the Columbus Senior Center took place on October 24, 1976 as part of the national bicentennial celebration.

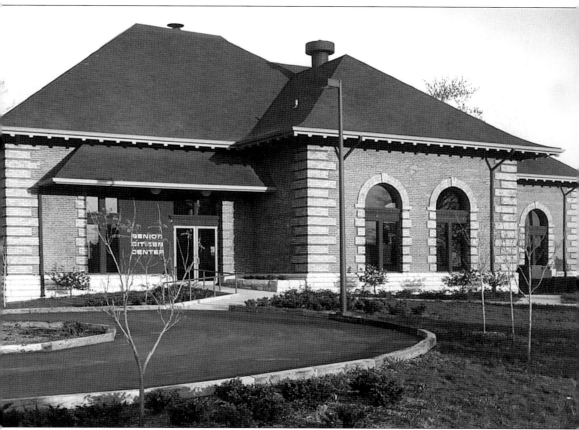

The Columbus Senior Center at 148 Lindsay Street stands near the gateway to Columbus from the west. Considerable interior remodeling took place to equip the building with ramps and an elevator. Workrooms and hobby rooms occupy the lower level. The main entrance is now at the southeast corner of the building convenient to the off-street parking area.

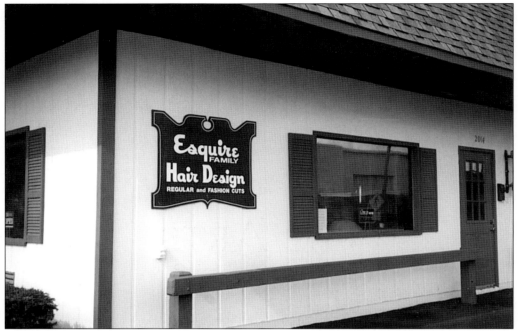

Even abandoned service stations have a second life in Columbus. Clapboard siding and a shake roof give The Esquire Hair Salon on Seventeenth Street a totally new identity.

Adequate parking space makes former service stations attractive to new businesses. This former station houses two unrelated businesses.

Five

THE ARTS

Although some residents jokingly called it "The Jawbone," Henry Moore's Large Arch has become a point of pride. Located on the brick plaza in front of I.M. Pei's Cleo Rogers Memorial Library, the five-and-one-half ton sculpture seems to knit together elements of historic and contemporary architecture. Behind it is the home of J. Irwin Miller's grandfather, banker Joseph Irwin. Across the street is the Eliel Saarinen-designed First Christian Church that touched off the Columbus architectural explosion in 1942.

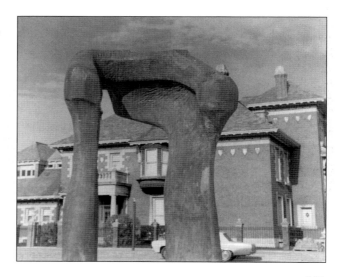

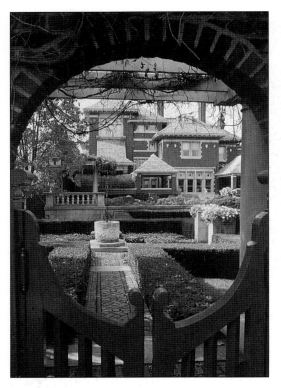

Surrounded by a high iron fence, the Italian sunken garden at the Irwin home drew visitors to Columbus for decades before the city became noted for its contemporary architecture. The ancient stone well (center) became known as a "wishing well" in the community. A masonry summerhouse, a bronze elephant, a marble fountain, wisteria-covered pergolas, circular fishponds, and a series of small pools and waterfalls are features of the picturesque gardens.

At the Bartholomew County Historical Society, visitors can see evidence of the community's early interest in art and design These stone relief carvings once adorned the Westside Foundry.

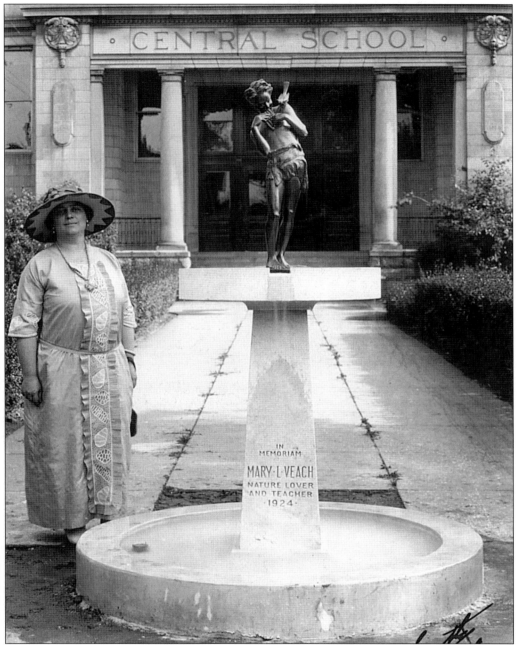

For nearly sixty years, this statue of Pan, the mythological shepherd who played a flute while he tended his flock, stood in front of the former Columbus High School (now Central Middle School). Created by noted sculptor Myra Reynolds Richards, the statue was presented to the school in 1924 to honor Mary Veach, a well-loved Columbus teacher. In recent years, Pan was moved to the herb garden at the Henry Breeding farm, then into storage in a school maintenance building. As plans develop for a new Central Middle School, interest is mounting in the community for restoring Pan to a suitable indoor location in the new school.

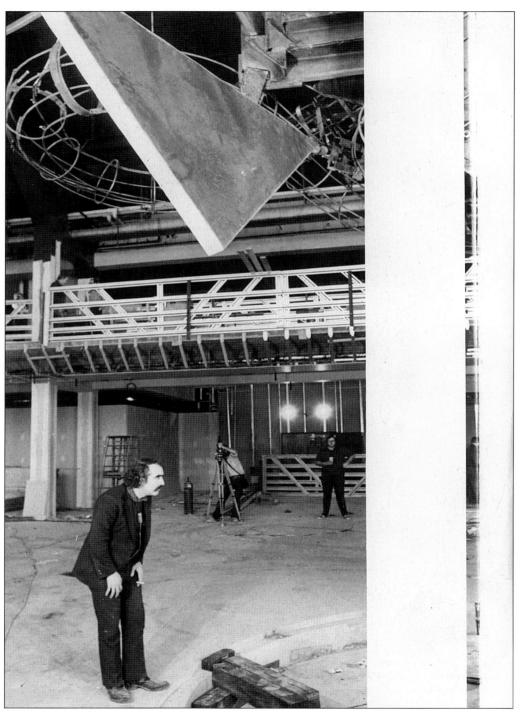

Chaos I, a kinetic sculpture made from scrap iron found in Indiana, was assembled by Swiss sculptor Jean Tinguely and his helpers in 1974. Early phases of the work were done in the abandoned Columbus Power House building (now Columbus Senior Center).

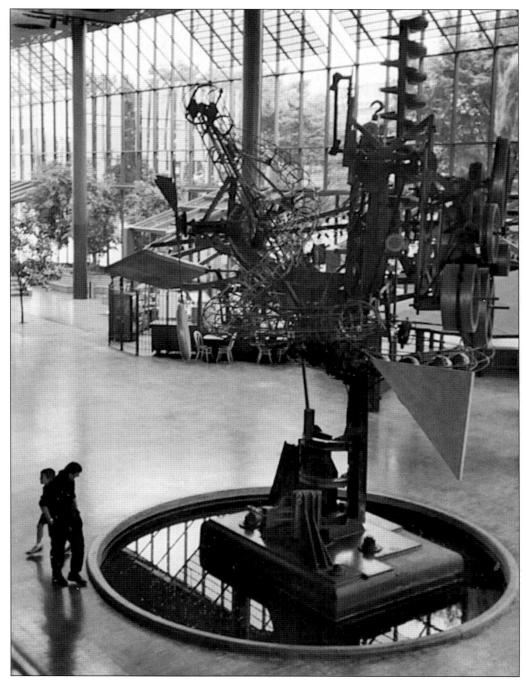

Weighing nearly seven tons, *Chaos I* towers two stories high in The Commons where its clanking gyrations and clattering metal balls fascinate residents and tourists alike. Tinguely considered *Chaos I* one of his best works. The *History of Bartholomew County, Volume II*, quotes him as saying, "Life is movement. Everything transforms itself, everything modifies itself ceaselessly, and to try to stop it . . . seems a mockery of the intensity of life."

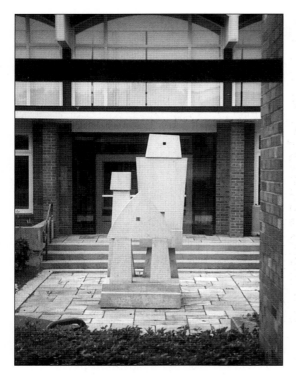

The Family, three angular figures representing father, mother, and child, stands in the courtyard in front of Parkside Elementary School. A gift of Mrs. J. Irwin Miller, the sculpture is rugged enough that children climb and play on it. The sculptor was Harris Barron of Brookline Village, Massachusetts.

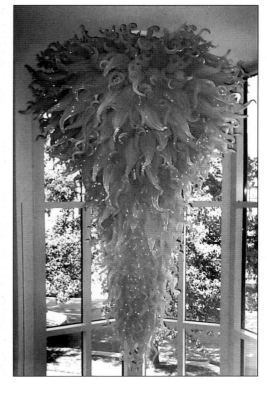

The Yellow Neon Chandelier, designed and executed by glass artist Dale Chihuly, weighs 1,200 pounds and is composed of 900 pieces of hand-blown glass. Shipped from Seattle and assembled in Columbus, it hangs in the Columbus Visitors Center.

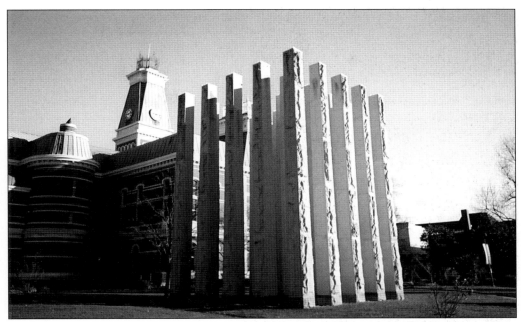

The Bartholomew County Veterans Memorial, completed in 1997, is a field of 25 limestone pillars, each rising 49 feet high. Designed by Thompson and Rose Architects of Cambridge, Massachusetts, the memorial graces a park designed by Michael Van Valkenburgh, also of Cambridge.

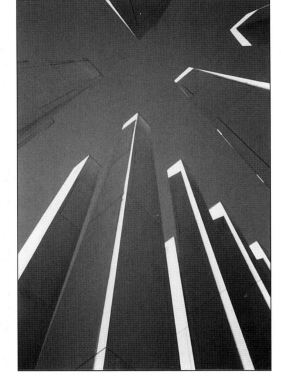

Inside the memorial, viewers' eyes follow the soaring pillars upward. Not only are names of veterans who died in service carved in the stones, but also included are letters from the servicemen and their families and excerpts from journals. The purpose is to promote greater understanding among future generations of the experiences and sacrifices of persons from their own community, county, and country.

Even a handball court can become a work of art in Columbus. Students from Jefferson School painted this whimsical one in the park that surrounds the Hamilton Center ice skating rink.

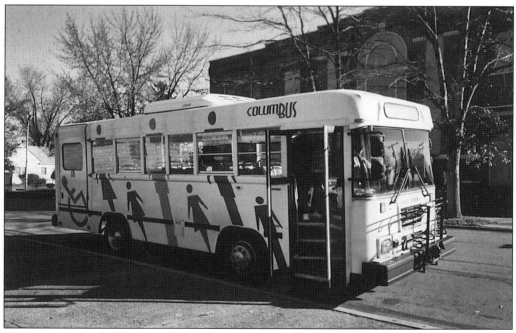

City buses sport playful art work also. They serve residents and also offer guided transportation for the estimated 50,000 tourists who visit Columbus each year.

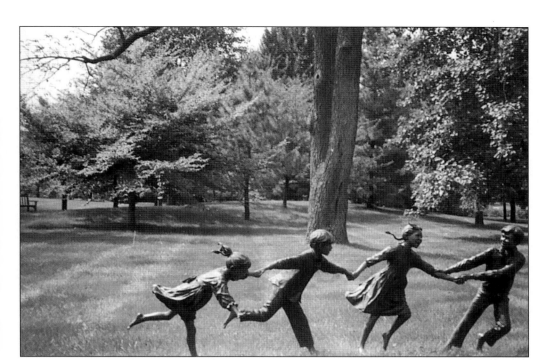

Crack the Whip, a sculpture by Jo Salyers, adorns the spacious lawns at ArvinMeritor's offices. The children's laughing faces are a reminder that real children once played here during recess from the former Garfield Elementary School.

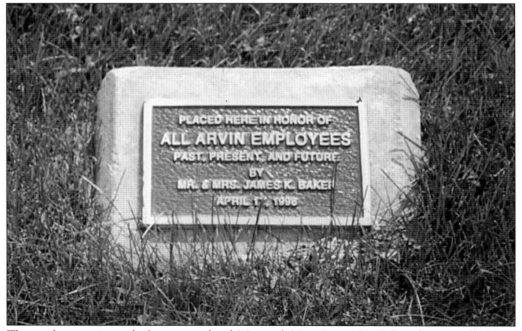

The sculpture pictured above, a gift of Mr. and Mrs. James K. Baker, honors all Arvin employees, past, present, and future.

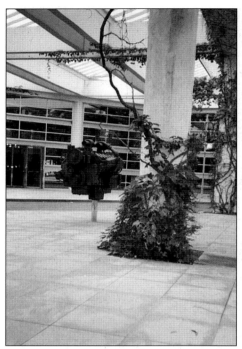

In front of Cummins, Inc. corporate headquarters stands a sculpture of a KV16 engine that was installed in 1984. This is an industrial engine, made for generators, not trucks. The sculpture was designed and built in England and shipped to New Jersey. Molds of each part were made and cast in bronze and then assembled. It symbolizes Cummins and introduces visitors to the museum inside, which is open to the public.

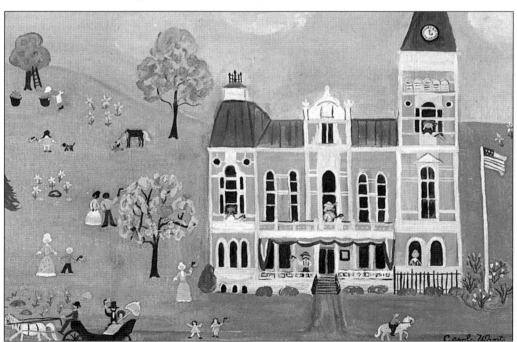

The Bartholomew County Courthouse is acclaimed as an undisputed symbol of the community and its people. It is the historical center of this thriving community that calls itself "Different by Design." This popular postcard was made from a 1977 original painting by artist Carole G. Wantz (from the collection of Mr. and Mrs. B. Sears).

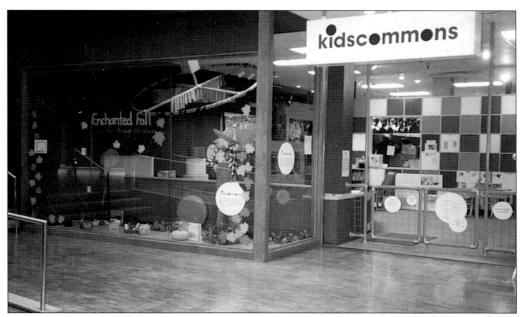

When children tire of the innovative playground located in The Commons, they can find challenging activities at kidscommons. Tucked between retail shops in this "indoor park," kidscommons challenges its young visitors to: "Explore! Create! Collaborate!"

So popular is kidscommons that an annex has been opened in an unoccupied store nearby, but in late spring 2005, the entire kidscommons was scheduled to move to 309 Washington Street. Kidcommons is the Columbus community children's museum for children ages 2 to 12. Funding in part has come from a $350,000 challenge grant from the National Endowment for the Humanities (NEH).

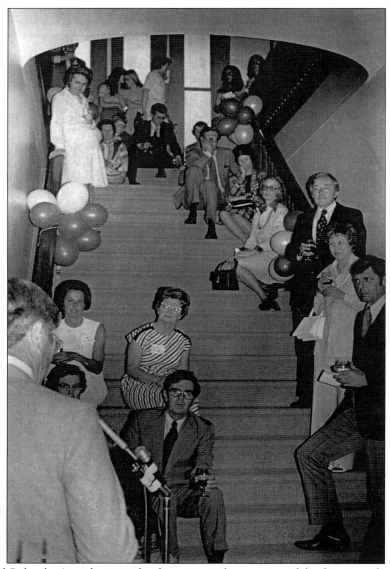

Evidence of Columbus's enthusiasm for the arts was the opening of the first out-of-town branch of the Indianapolis Museum of Art (IMA) on September 22, 1974. Local residents who began exploration of the possibility of an IMA branch in Columbus were Mrs. Richard Heise, Mrs. Sherman Franz, Mrs. James A. Henderson, and Mrs. James K. Baker. At the dedication of the gallery, located on the second floor of the Columbus Visitors Center at Fifth and Franklin Streets, IMA director Carl Weinhardt said, "The idea of creating a museum extension located in another city, I believe is totally unique. . . . That this program has begun in Columbus is especially fortunate." The Indianapolis museum agreed to prepare, transport, and install several different displays each year. In 1993, the Columbus gallery moved to a new 7,000-square-foot facility on the second level of the downtown Commons Center. It was a gift to the community from Xenia S. Miller and Clementine Miller Tangeman. Exhibits at IMA-CG usually draw about 10,000 visitors each year. One glass show, however, Dale Chihuly's (see page 106) *Seaforms*, attracted more than 10,000 viewers during the 16 weeks it was displayed.

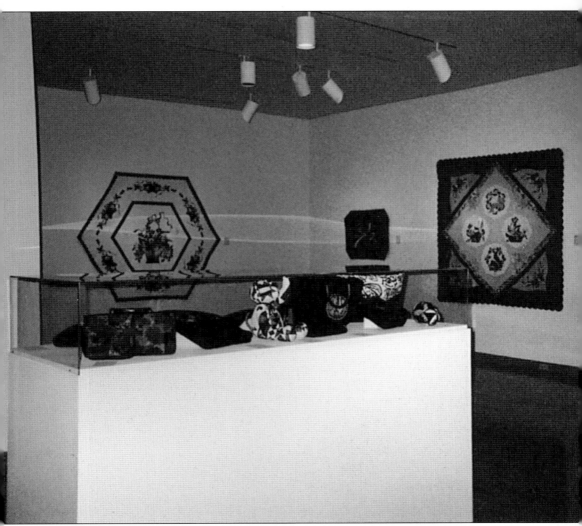

Pictured is a textile exhibit at Indianapolis Museum of Art, Columbus Gallery. The Gallery sponsors art educational resources and field trips for school children in the Bartholomew County School Corporation.

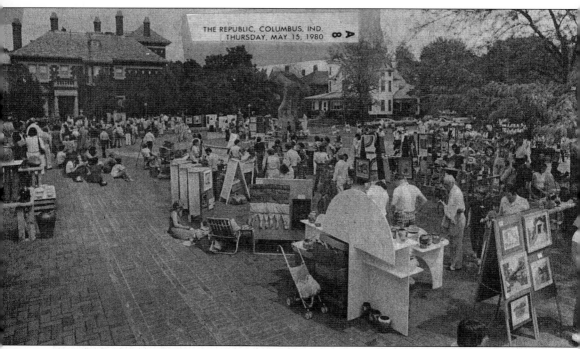

The Plaza of Cleo Rogers Memorial Library hosted hundreds of residents and visitors at this 1980 outdoor art show. Architect I.M. Pei compared the Library Plaza to vital public plazas used for community events in European cities. The Irwin home is in the background at left, *Large Arch* is at center, and the Prall home is at right.

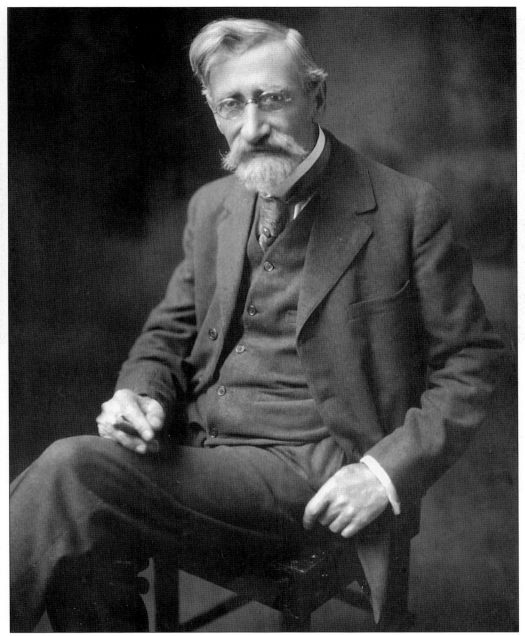

Interest in the arts in Columbus flourished as early as the 1920s. Dean of the Brown County artists' colony, T.C. Steele, actively supported the Sketch Club of Columbus High School. Organized in the 1920s by Miss Lillian Volland, longtime art supervisor in Columbus schools, the Sketch Club became an organization for artists and patrons. Its yearly exhibits, held in the old gym on the lower level of Columbus High School (later Central Middle School), were popular. At the 1925 annual Sketch Club banquet, 51 paintings by Brown County artists were displayed. Speaking on behalf of the artists, Mr. Steele, then 78 years old, said, "Beauty is the sole excuse for art, and (that) is the beauty of the artist to satisfy the soul of man."

The Columbus Art League, formed just three weeks after the 1925 Sketch Club exhibit, cooperated with the Columbus Library to promote art and literature. One of the organizers of this 1929 exhibit was Evelyn Seward (right), who taught French and Latin at Columbus High School.

Foreign language teachers at Columbus High School focused on holiday customs in other countries to enrich the experience of their students. Pictured here in 1958–1959 are as follows: Alta Redmond, French (standing); Evelyn Seward, French and Latin (right); George Utterback, Latin; and Frances Taylor, Spanish.

Latin students frequently participated in a Roman banquet. This one took place in the classical surroundings of the Irwin home. Seated is Miss Elsie Sweeney (at rear, right), descendant of Joseph Irwin and patroness of the arts in Indiana.

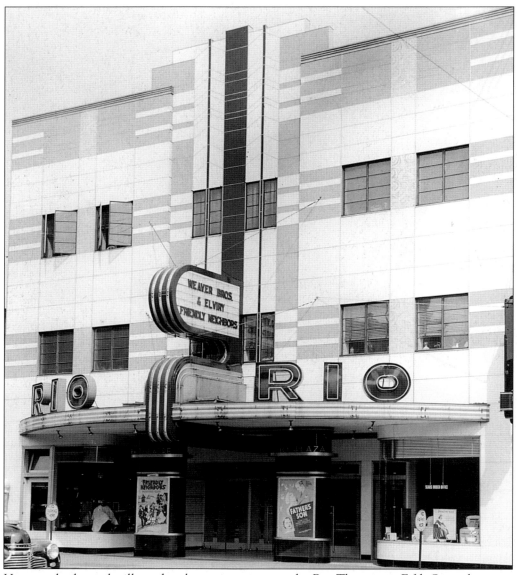

Home to both vaudeville and early motion pictures, the Rio Theater on Fifth Street between Washington and Franklin Streets started as the Orpheum Theatre. Later it became the American Theater and then the Rio. In the lobby, an overhead map depicted Hollywood landmarks on lighted frosted glass. The theater closed in 1958, except for occasional special films. In 1964, the Columbus Arts Guild, which had organized in 1960, acquired the theater for productions of its theater division. In 1971, when lease agreements could not be resolved, the Arts Guild voted to terminate its lease and moved productions to a theater building at Bakalar Municipal Airport. The Rio Theater was later demolished and replaced by the drive-in window and parking lot for the Home Federal Savings & Loan Association at the northeast corner of Fifth and Washington Streets.

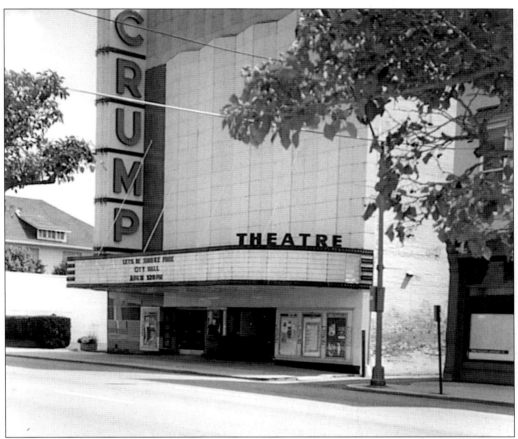

The original Crump Hall or Crump Opera House, built by Francis Jefferson Crump, burned in the 1880s. Francis' son John Crump founded the Crump Theatre (above) in 1889. (Its Art Deco façade was added in a 1934 remodeling.) The opening presentation by the Norcross Opera Company drew criticism because some female cast members appeared in circus tights. This was not considered acceptable apparel for the Crump Theater at that time. In June 1897 and again in February 1898, John Philip Sousa and his band performed in Columbus at the Crump. Local talent shows, popular during the early years of the 20th century, frequently played at the Crump. Until an auditorium was included in the remodeling of Columbus High School, class plays were presented there also. The oldest preserved program of these is dated May 2, 1913. The cast of *Every Student*, a type of morality play, included Helen McEwen, Lorene Moore, Chester Amick, Virgil Morris, Harry Hege, Raymond Morris, Lloyd Brougher, Stella Taylor, Clara Newsom, Louise Mason, Rachel Quick, Annis Baxter, Fern Wright, Florence Rost, Carrie Meyers, Ray Friedersdorf, and Vera Newsom.

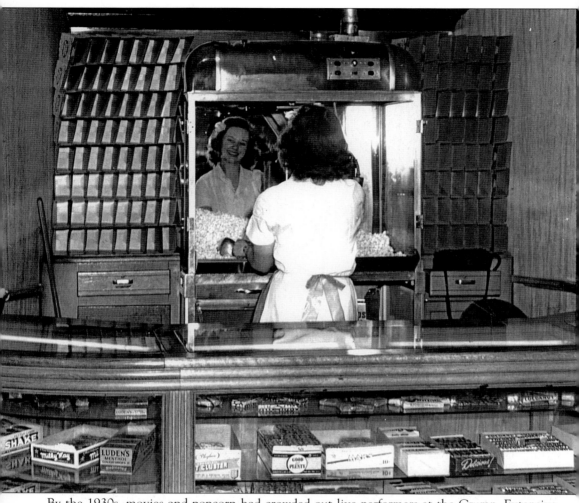

By the 1930s, movies and popcorn had crowded out live performers at the Crump. Extensive remodeling and enlargement had created an added attraction and public service on the mezzanine—a "rest room" open during the day at no charge where "shoppers could rest, meet friends, play cards, or listen to that new entertainment medium, the radio." The theater presented movies into the 1990s. Other events continued to take place at the Crump such as "cooking schools, radio station events, and organization and business programs needing a large seating area."

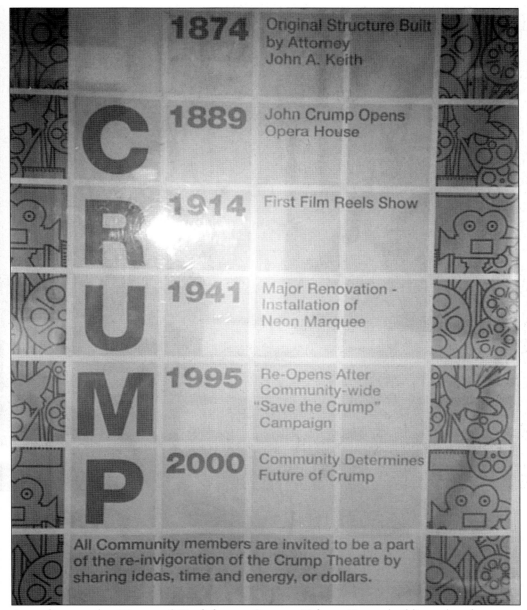

C	**1874**	Original Structure Built by Attorney John A. Keith
	1889	John Crump Opens Opera House
R	**1914**	First Film Reels Show
U	**1941**	Major Renovation - Installation of Neon Marquee
M	**1995**	Re-Opens After Community-wide "Save the Crump" Campaign
P	**2000**	Community Determines Future of Crump

All Community members are invited to be a part of the re-invigoration of the Crump Theatre by sharing ideas, time and energy, or dollars.

According to the *History of Bartholomew County, Volume II*, no building played a more important role in entertainment in Columbus than the Crump Theater. In the early 20th century, usually three or four traveling theatrical companies per month played the Crump, including the popular minstrel shows. A parade up Washington Street often preceded these. The residents of Columbus seemed to take a proprietary interest in the Crump, and a proposed name change to the Von Ritz after the 1934 remodeling failed to meet with community approval. In 1987, the Crump was recognized as being the state's oldest movie theater in continuous operation, though limited by then. Some interested citizens mounted a campaign in the 1990s to "Save the Crump" by recognizing its significant history and hoped to revitalize it. This has met with limited success, however.

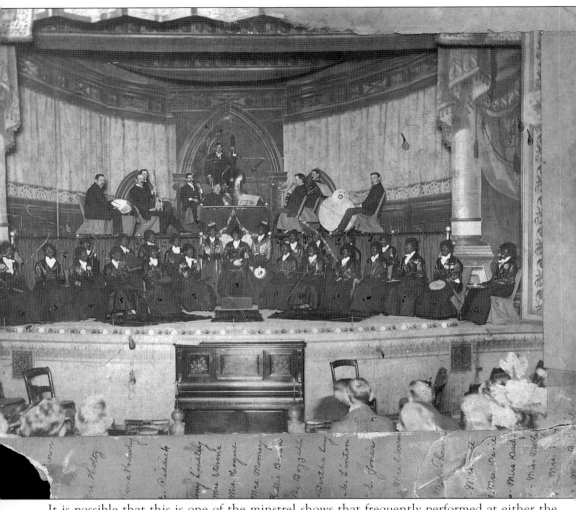

It is possible that this is one of the minstrel shows that frequently performed at either the Crump Theater or the Schwartzkopf Opera House. According to William Marsh's book of memoirs, *I Discover Columbus*, road shows were still playing the opera house "until 1903 or thereabouts." Marsh also described the opera house as having "a flat floor with loose chairs." The term "opera house" was loosely used in those days. Many were simply small upstairs auditoriums that presented entertainment of almost any variety. The Schwartzkopf Opera House, however, had a long and colorful history in Columbus until it was razed in part of the downtown redevelopment during the 1970s. G. Chester Kitzinger, Columbus native and first maestro of the Columbus Symphony (see page 124) led an unsuccessful effort to preserve the structure. It was located in the 200 block of Jackson Street.

Columbus City Band members performed at a Democratic rally at French Lick Springs Hotel during a national election campaign. One of the band's forerunners, the Big Six Band, originated in 1888. Two of its members, Ephraim Davis and Ed Redman, contributed to the history of music in Columbus: Davis helped organize the Columbus High School band; Redman left part of his estate to further music "in the hearts of Columbus school students."

Crowds gathered on the Plaza of the Cleo Rogers Memorial Library in the 1970s for a Popfest performance of the Indianapolis Symphony Orchestra. The symphony's annual concerts for Columbus schoolchildren had begun in 1962 with the support of generous patrons who also provided transportation to the concerts for all schoolchildren at no charge. The Columbus unit of the Women's Committee of the Indiana State Symphony was organized in 1937 by Miss Elsie Irwin Sweeney.

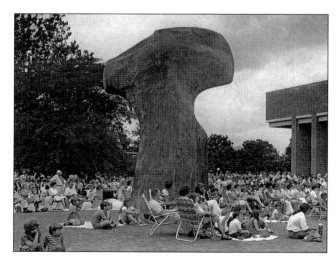

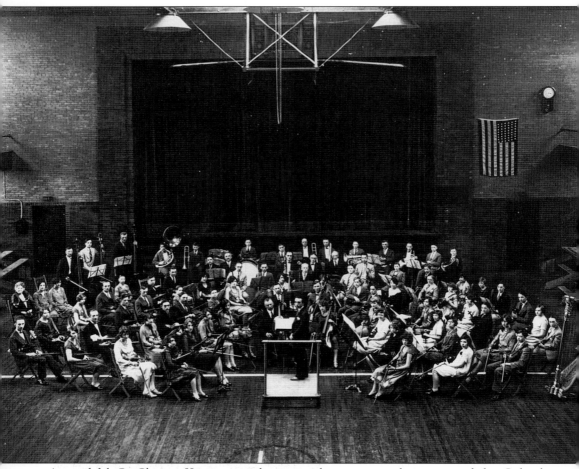

A youthful G. Chester Kitzinger is shown conducting an early concert of the Columbus Symphony Orchestra (CSO) in the Pearl Street Gymnasium opposite Columbus High School (now Central Middle School). Kitzinger's long list of contributions to music in Columbus ended with his death in 1977 at age 83, but his legacy lives on. He founded the CSO, recognized as the oldest symphony orchestra in the state, in 1922. It was thought to be the first in the United States in a city of Columbus' size at the time.

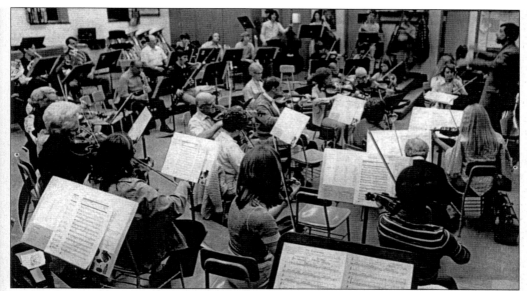

The original CSO ceased performances in 1954, but Columbus Pro Musica was founded in 1970 with two goals: to rejuvenate the CSO and to sponsor instruction in the stringed instruments in the area schools. Dale Spurlock, shown above conducting an April 1976 rehearsal, came to Columbus to direct the revived CSO. At its first concert, Director Emeritus Kitzinger played in an honored place in the first violin section. Spurlock retired in 1992 after 22 years of service.

On June 1, 1979, the Columbus Youth Orchestra, conducted by Dale Spurlock, played a free noontime concert on the Cleo Rogers Memorial Library Plaza.

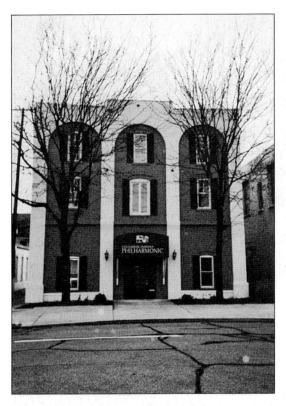

In May 1995, the Pro Musica Orchestra, organized in Columbus in 1987, adopted the new name of Columbus Philharmonic. Nurturing the role of the arts in the intellectual development of young people had long been a Pro Musica priority. As well as instrumental and vocal experience in the schools, the Philharmonic, headquartered in downtown, sponsors music day camps, Saturday morning concerts for children and their families, and docents who visit the classroom to prepare students for what they will hear.

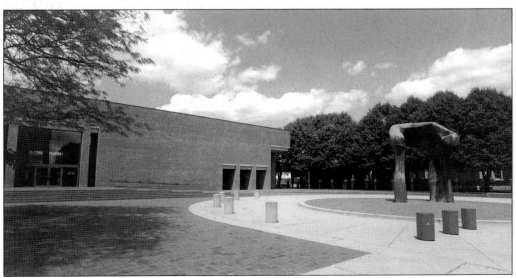

The Cleo Rogers Memorial Library Plaza offers a spacious venue for many musical events and art fairs. At right, behind the trees, is the Irwin home and gardens. (See page 102.)

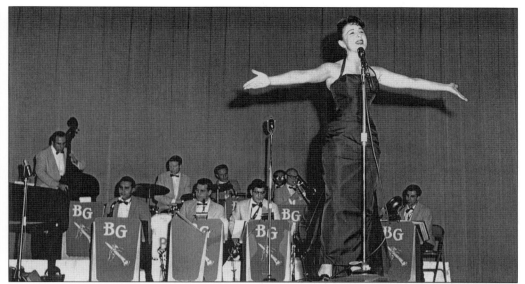

Between 1955 and 1960, the Junior Chamber of Commerce (Jaycee) Auditorium Series brought topflight entertainers to Columbus. Above, Eydie Gorme entertains a packed house at Columbus High School's Memorial Gymnasium on December 7, 1957. Season tickets for the best seats for a season series were $10. Among other series attractions were Fred Waring and his Pennsylvanians, Bob Hope, Arthur Fiedler and the Boston Pops Orchestra, Guy Lombardo's Royal Canadians, flamenco dancer Jose Greco, and Louis Armstrong.

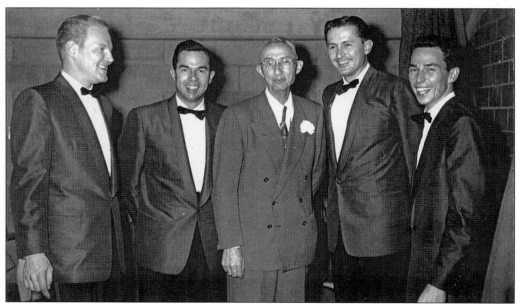

Columbus' own celebrities, the Four Freshmen, appeared in the Jaycees' Series on April 19, 1956, along with Nat King Cole and the Ted Heath Band. Pictured, from left to right, are: Ken Albers, Don Barbour, proud father Harold Barbour, Bob Flanigin, and Ross Barbour. Don and Ross came from a musical family, and their first quartet included their parents, Harold and Maude Fodrea Barbour.

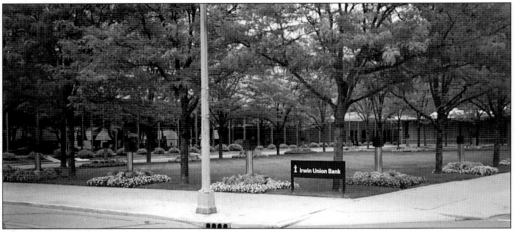

The Irwin Union Bank and Trust Company at Fifth and Washington Streets blends into a garden of groves and flowers, a design of landscape architect Dan Kiley of Charlotte, Vermont. A grove of little-leaf lindens surrounds seasonal displays of geraniums, spring bulbs, and chrysanthemums, providing a colorful and spatial area in an urban environment. Installed by Maschmeyer-Wedco, Inc. of Columbus, the project received a certificate of merit from the American Association of Nurserymen in 1971.

The late J. Irwin Miller was fond of the quote engraved on this plaque: "Where the good things are, there is home." It is from a play by Euripides and sums up Miller's belief in the importance of helping to improve the quality of life in a town. This plaque of appreciation for the generosity and inspiration of Mr. and Mrs. Miller and Mr. Miller's sister, Clementine Miller Tangeman, is located in The Commons.